Max Ferguson's Digital Darkroom Masterclass

For my sons Matthew and Toby.

Also for Susan,
who lent me her father's old Rollei

Max Ferguson's Digital Darkroom Masterclass

An illustrated guide to photographic post production

Max Ferguson

Focal Press

OXFORD · AUCKLAND · BOSTON · JOHANNESBURG · MELBOURNE · NEW DELHI

Focal Press
An imprint of Butterworth-Heinemann
Linacre House, Jordan Hill, Oxford OX2 8DP
225 Wildwood Avenue, Woburn, MA 01801-2041
A division of Reed Educational and Professional Publishing Ltd

℞ A member of the Reed Elsevier plc group

First published 2000
Reprinted 2001

British Library Cataloguing in Publication Data
A catalogue record for this book is available from the British Library

Library of Congress Cataloguing in Publication Data
A catalogue record for this book is available from the Library of Congress

ISBN 0 240 51569 2

Typeset by Florence Production Ltd, Stoodleigh, Devon
Printed and bound in Italy

FOR EVERY TITLE THAT WE PUBLISH, BUTTERWORTH-HEINEMANN
WILL PAY FOR BTCV TO PLANT AND CARE FOR A TREE.

Contents

duction

When Focal Press invited me to present a synopsis for which my working title was Silver to Silicon, I thought, another Photoshop manual. After careful consideration I thought what the world doesn't need is another Photoshop guide.

I didn't particularly want to spend all my time going through all the tools, dialog boxes, menus, layers and so on. I do enough of that when I lecture. Adobe do supply a suitable, laminated sheet with the software. Instead I will introduce tools with their options, filters and keystrokes, as each process requires, thereby giving their usage a suitable context. I will assume that you have a moderate knowledge of the program, but are looking for creative direction. I will also assume that you have a moderate knowledge of how to drive your computer. Getting into a system of good housekeeping with your disk maintenance utilities, file saving and backup goes without saying. The PC vs Mac debacle won't be entered into.

Arrive at a comfortable method of navigation around your system and good habits when it comes to saving your files. At home I am not the most tidy of people, but working in a darkroom for twenty seven plus years has made me very ordered at work. This has been transferred to keeping my Mac happy.

I was informed that, originally, this software was going to be called Printshop. Another company developer had laid claim to the title, so the name Photoshop was chosen. Unsharp Mask, which has its roots in pre-press work, is an example of how Photoshop uses analog-based tools to describe the digital machinations of the software. You will notice that most of the tools I use in Photoshop are firmly based in analog methods and in essence achieve the same results.

As most of my work has been commercial, ending up as printed matter, I was interested in the area between 'click and ink'. I found myself at the Center for Creative Imaging in Camden, Maine, attending a workshop, presented by Adobe's Russell Brown – you will see his name on the Photoshop title screen as it boots up. At the time it was only Photoshop 2 and 60 Mb of RAM was huge. I did suggest to Russell that it could do with a dodger. Without laying claim to being an inadvertent developer I did notice that burn and dodge tools were present in Photoshop 3.0.

After this informative sojourn in America I continued to work in the darkroom where I could work much faster and had beautiful bromide papers to work with. I was aware that the future was snapping at my heels.

On a visit to Ilford UK headquarters I saw a collection of superb Iris prints from photographer John Swannell. Finally here was an output that had all the touch and feel of a fine art print. The Iris printer, originally conceived as a pre-press proofing machine, convinced me that computers could deliver the quality and control that has finally allowed me after twenty seven years to leave the darkroom. Creative people acquire and bend technology to suit their own purposes.

This book has been conceived as a companion to Martin Evening's *Adobe Photoshop 5.5 for Photographers*, which gives an exemplary breakdown of the elements of the program, with photographers specifically in mind. Martin's book sits by my computer, as a constant source for tips. As a reference it's invaluable.

While presenting a Photoshop workshop to some eager amateur photographers, I noticed one young chap had so many deft keystrokes that I eagerly awaited a screaming guitar solo followed by the well-known piano 'outro' to Eric Clapton's *Layla*. Superficially his knowledge of the program far exceeded mine. In his enthusiasm he had failed to observe what was actually happening on his monitor. I gently reminded him that the idea was to 'make pictures'.

Once upon a time, a photographer said to me while I labored on his image, 'That's a lovely print, Max. Could we see the product?' I lifted it from the wash absolutely aghast. I had worked really hard to make something special. This was followed by 'That's what the client is paying for.' I looked harder and realized that 'the product' had become overpowered by trying to make it all look wonderful. This was a salutary lesson in restraint.

Since then I've tried to work out what the picture is trying to say. I've also noted that the client is often trying to promote or sell something. The process is not the issue. The result is what is important. I apply the same attention to the result, whether the print is going into a private collection or the client is selling toothpaste.

Since becoming involved with digital media the same sensibilities continue. It is very easy to get carried away with being clever at times. Photoshop allows many avenues for exploration that can head into digital fairy dust, which doesn't make an image any better. This fantastic program can give remarkable control over the way we enhance our photography, but bear in mind it is about making pictures.

As with all books, start at the beginning and work through it. I would suggest that even in the easy sections there is something for the well-versed Photoshop user, even if it just gives another way of looking at something that you do as a matter of course. When you are familiar, dip into the section you need.

As someone who has worked in the 'imaging' business for a long time I have come to the conclusion that very little is original. Most of what we do comes from other sources and is applied until it has found a place in our own visual literacy. I must admit to pillaging other people's ideas and using them until I have my own slant on them. So these methods are not hard and fast rules, but a source for your own creativity. Borrow and purloin at will.

Sometimes, I return to the darkroom just to do things the hard way. It often gives me a fresh approach. This book is about translating those ideas into Photoshop. I've purposely started with a chapter on a darkroom method that I devised as a result of observing a student's happy accident. The sections on layers, selections and curves are firmly based in this split grade method of printing. These are my prime tools, the tools that I really use to shape the image. The other tools, although important, are used to temper the big ideas and moves that these three main tools allow. This is after all a digital darkroom guide.

The picture sequence is designed to give a walkthrough method. Some of the tools, filters and sequences are repeated but in another situation. This 'organic' approach is devised to show how each image was made. The chapter on layers, for example, is about how some layers have selections that keep them independent. Some layers are used to adjust the layers below it, whereas some are designed to blend with other parts of the image. It can be seen that I use large layer stacks with many adjustment layers often with the original image at the bottom of the stack. Rather than pull the pixels in one direction and then push them in another, with each edit progressively degrading the original information, I try to keep pixel editing to a minimum to preserve the integrity of the original.

Although some methods might seem cumbersome, they have a purpose and allow me to change my mind until I am satisfied with the result.

Despite the power of today's computers, be aware that some tasks are still labor intensive. A good Quick Mask selection can still take time to paint. Mistakes, however, can be easily repaired, and selections can be saved for future use. This is a far more pleasant prospect than painting onto an expensive, bromide print with a thick, solvent-based solution, where a mistake means starting afresh.

The special effects wizards responsible for the stunning visuals in the new *Star Wars* series import sequences into Photoshop to create masks for the digital effects to be overlaid on original footage. Attractive people that grace the covers of magazines seem, these days, to owe their continuing looks more to Photoshop than cosmetic surgeons. In fact, this particular software is omnipresent in all aspects of current media production. Images can be imported from other software packages, exported to web design and sent to clients based in other cities and countries. Photoshop allows really creative people almost unlimited avenues to explore their visual ideas.

All the images and graphics in this book, even the darkroom chapter, were created in Photoshop. It was actually easier emulating test-strips and sepia tones with my computer than to go into the darkroom. I've included this chapter to illustrate a concept. I have also made my livelihood from splashing about with chemicals. It is where the methods illustrated have originated.

Photoshop can be used in many exciting ways. I've aimed this particular book at darkroom workers, enthusiasts and professionals. I trust that it will bring you out into the light.

Acknowledgements

The photographers in alphabetical order: Mark Anthony, Jon Bader, Dan Burkholder, Bob Carlos Clarke, Tobi Corney, Graham Goldwater, Phil Jude, Spencer Rowell and Norma Walton.

John Lunn for the CD preparation.

Matthew O'Donnell of Epson Australia, and Tony McLean of Visualeyes for color management advice.

Brian Cooke, Tony McLean, Leander Newlyn and Simon Perfect of Visualeyes for letting me help myself to everything.

John Couzins for the lovely old glass negative.

Pete Langman for his ancestor and for being a damn good bloke.

Martin Evening for encouragement, setting a scary standard and a starting point.

Tanya Carter for her ungrudging support.

A big thank you to Leesa Loh of Blackie McDonald, Sydney, and Adobe Australia for a copy of Photoshop 5.5.

Greg Furney of Brooklet House Editions.

Marie Milmore of Focal Press for patience and feedback.

Ray Davies, Graham, Jerry Hall, Paula Hamilton, Hermione and Jade Jagger.

Susan Roxon for proof reading and correcting my wayward commas.

Special thank you to my Mum for an office, hot food and cold beers while I did this.

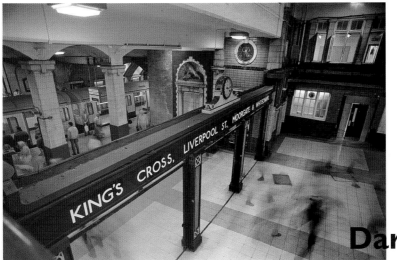

Darkroom

This introductory chapter is a visit to the darkroom to explain some of the thought processes and methods I've tried to incorporate into my own use of Photoshop. It is an example of how observing a mistake by a student from a Summer School I taught at, led to a common darkroom practice. A fine example of observation, a little bit of theft and some lateral thought. So much so that I have been fortunate enough to lecture on split grade printing all over Britain.

Trevor, a chemist from Pontypridd, had printed a very pleasant landscape. Unfortunately, the flowers in the foreground were a little burnt out. It was suggested that he dial in a low grade filter, this would enable the flower's highlights to be burnt in with more ease. He returned shortly after with a splendid print. When I asked what he had done, he replied, 'I printed the whole picture on Grade 0 and then printed the whole picture on Grade 2.' I was somewhat baffled, and didn't think any more of it for some time.

About two years later I was having trouble toning a print. The shadows looked flat and washed out. I remembered Trevor's happy accident and realized that I could over-print, with multigrade products, a hard grade for the shadows on top of a softer grade for the highlights.

I realized that I needed to devise a method to predict how to do a test strip. I remembered a test strip method shown to me by the well-known printer Gene Nocon. If you can find a copy of his book *Photographic Printing* it is very informative. The chapter I found most useful is entitled 'Things that Go Bump in the Dark'.

While at the Center for Creative Imaging, I discussed this process with Richard Benson. He pointed out that this was similar to the Duotone facility in Photoshop.

Often exposing a print at a normal grade 2 is not satisfactory in shadow density or highlight detail. At best it is a compromise. Photographers and printers familiar with characteristic curves will know that materials with a steep curve have a high contrast. Lithographic papers and films are a perfect example.

Grade 1 paper would illustrate materials with a shallow curve.

Multigrade products have variable curves. With a filter pack, paper can be exposed at grade 0 through to grade 5. The clever aspect of this is that the paper can be exposed at different grades on the same sheet, i.e. expose with a grade 1 filter for highlights with detail, and then exposure with a grade 5 filter delivers denser shadows.

Expose the paper for an overall 10 seconds with a low grade filter. Continue the step test across the image with 2 second increments. Dial in high grade filter, shield the bottom of the print – a lot of information can be read from the single grade test across the bottom of the print – step test upward with increments of 2 seconds.

Exposure choice of the highlighted square shows 18 seconds low grade, plus 8 seconds high grade. Test square by exposing all over for low grade, i.e. 18 seconds, and half the image for an extra 8 seconds on high grade. Final adjustments to grade and exposure time can be assessed from the second test.

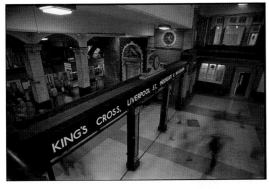

The original combined exposures for split grade print.

When toning, overexposure is often required when using toners that require bleaching. Not all the image redevelops when the print is placed in toning baths.

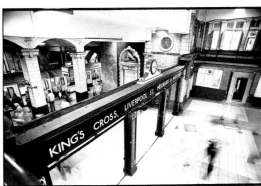

Bleach print with one part potassium bromide plus one part potassium ferricyanide diluted in water. Dilute enough water to allow controlled bleaching. If solution is too strong the image will bleach too far before it can be halted.

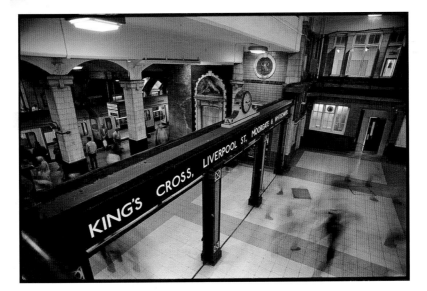

Before toning with thiocarbimide rinse thoroughly. I use non-smell toners from Fotospeed and Rayco. These are two component toners. Part 2 can change the basic toner – Part I from yellow brown to dark earthy browns. Wash thoroughly in running water and air dry on blotting paper or screen.

Viewed as a straight print, London's Boston Manor station initially appears bland and uneven on the viewer's left-hand side. This can be corrected by giving more exposure to the right-hand side of the print. The image is now balanced but it is still rather uninspiring. Darkening the top of the print adds a great deal more drama. Cutting a piece of card or careful shaping of your hand under the lens to shield the lower part of the image allows extra exposure to be added to the sky.

The area burnt in is illustrated with a screen grab showing the demarcation between sky and foreground using the Lasso tool. This comparison will become clearer in future chapters.

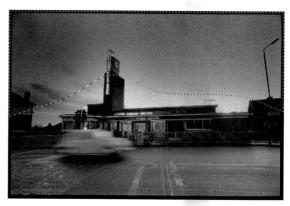

Shading or burning can be best achieved by moving your hand or a piece of card gently to give a soft edge to the extra exposure. As the plane of focus is where the paper is held in the masking frame, keeping your hand near the lens further enhances the soft edge effect. A piece of card cut to the shape required and used in the same way is far more predictable.

Note. Cut the card shape smaller than the print. This is easily achieved by holding a piece of card near the lens, with enlarger on and drawing the area needed. By cutting a card close to the same size and holding it close to the print, a halo can be put around the building. This is a technique often used in printing the work of French photographer Jeanloup Sief.

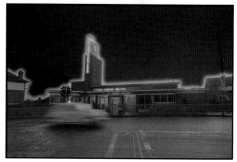

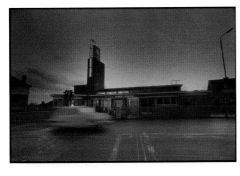

The sky is burnt in on both grades. Determine the exposure from the gridded test strip. A square from the test strip, with more exposure than the initial two grades chosen for basic exposure, indicates an increase of exposure for the sky. In this example an extra 8 seconds at grade 1 and an extra 10 seconds at grade 4 add menace to the clouds.

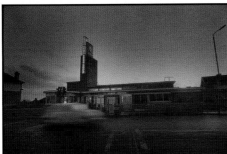

The foreground was burnt in with added exposures of 6 seconds at grade 1 plus 6 seconds at grade 4. Now the print doesn't appear too top heavy.

Adding judicious extra exposures to the corners, your eye will now unconsciously return to the highlight, i.e. the glow around the tower and the lighting on the front of the tower.

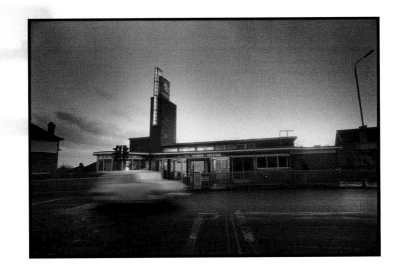

Before thiocarbimide toning the print was first toned in Kodak selenium toner at a dilution of one part toner to nine parts water. Although on neutral papers this appears to have little effect, when bleached strong red tones appear in the lower mid-tones. Selenium toner also retards the bleaching of the darker tones.

A stronger 'split' in the tones will show in the final print. Using selenium toner first gives a reddish base color under the browns of thiocarbimide toning. It is a good idea to use test strips and test prints to determine how long to leave in selenium toner before thiocarbimide toning.

This print of Northfields station is another fine example of industrial architecture of the 1930s. Overall it was given a similar treatment to the photograph of Boston Manor station.

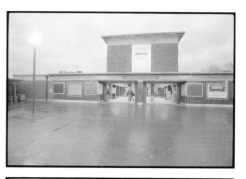

The treatment was made heavy and dark to emphasize the overcast twilight, a weather condition familiar to every Londoner.

By overprinting the sky, the misty glow of the streetlight is emphasized, as is the glass panel lit from inside. The exposure was biased in favor of the hard grade to make the building even more solid and monolithic.

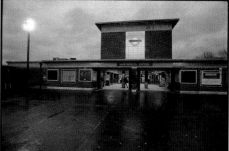

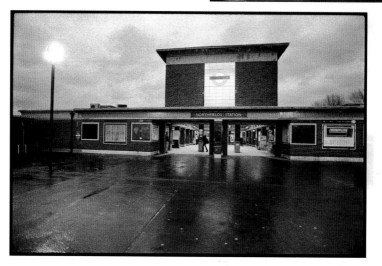

The final color was achieved by first toning the print in thiocarbimide and then in a Rayco blue toner. This toner is a two part solution, mixed just prior to use.

Blue toner leaves a nasty green cast that can only be removed by gentle washing in running water. The print needs to be agitated regularly or it washes out unevenly. Also inspect constantly, as too much washing will remove the blue toner completely. This print was left long enough to just wash out the highlights and leave a blue in the mid-tones which became green when mixed with the underlying sepia color.

I strongly recommend air drying toned prints. Force drying with heat can alter colors dramatically.

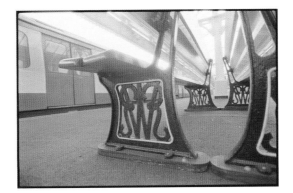

This treatment is a variation of split grade printing. The seat detail with an iron cast Great Western Railway logo is one of the many old furnishings progressively disappearing from London's underground system. Although this is not a nineteenth century French garden, a treatment reminiscent of the photographs of Atget, I thought, would give this the feeling of age.

Grade 5 was dialed in with the usual 10 seconds + 2 second intervals across the image.

The masking frame was then placed under another enlarger, with the column raised enough for the light source to cover the print, with the lens set at minimum aperture and grade 0 filtration. A white light step test with 2 second intervals was made up the paper. This gives gentle highlight tonality with strong blacks from the high grade exposure. The print has a controlled fogging. The fogging can only be achieved from white light. It is not the same as exposing the negative for the highlights on grade 0.

To test the chosen exposure, shown with the highlighted square, the next test was exposed at 22 seconds with grade 5 filtration, then fogged for 10 seconds with the white light enlarger.

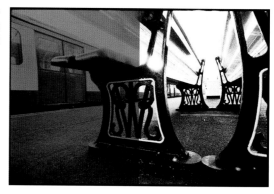

As with the split grade test, half the image is blocked off to test that the basic exposure as well as the cumulative effect of the second exposure are enough. Basically the second test is to check over a larger area that the assumption made from the first test is correct. Minor adjustments are easier to see from this second test.

Once the correct exposure has been confirmed a final print can be made. For this print a strong black was required to enhance the strong diagonal lines and the repeating detail in the seats. Before toning the print appears dull, flat and heavy.

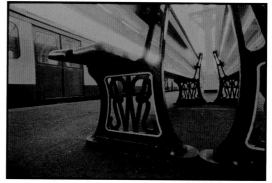

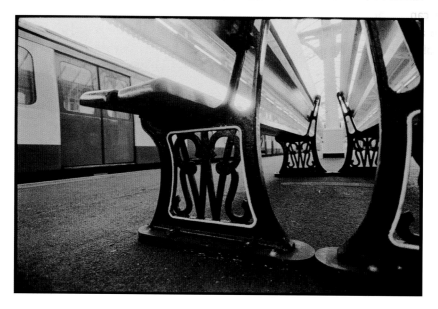

The toning process with this image was a repeat of selenium and thiocarbimide, this time with a long selenium toning time and only a light bleach – just enough to bleach highlights and higher mid-tones. The controlled fogging has exposed silver halides in all the highlight areas. This would not happen as evenly with an exposure through the negative on the lower grade. When these are bleached and redeveloped in the toner they return with the toner color, and not quite as heavy as prior to toning.

All photographs in this section are by Graham Goldwater, and originally hand printed on Ilford Multigrade 4 fiber-based paper. They are a small sample from an exhibition of London's Underground.

For ease of preparation of this chapter it has been easier to replicate the prints in Photoshop than to scan every test strip and print. The original prints were used as a guide to accuracy for tones and print quality.

Split grade printing has now become my basic printing method. It does require perseverance to learn to read the information properly. Learning a technique is easy. Learning to 'see' takes time.

A few final darkroom tips

As a basic guide to the test strip my starting points are as follows:

Stop lens down three stops. Most lenses work at their optimum closed down three stops.

First exposure is 10 seconds. Less is not enough time for dodging during exposure. If this is too dark stop down further. If too light, open lens one stop or increase basic exposure.

Start with grade 2 – Normal and grade 4 – Hard. Retest with different combinations if required.

Finally, use a minimum of two grades between hard and soft grades, e.g. 2–4, 3–5. Greater differences can be used, e.g. 1–4, even 0–5 can lead to interesting posterized effects.

For blue toner the manufacturer recommends a dilution of one part solution to four parts water for both A and B solutions before mixing them in a tray. I have found that one to eight gives a slower time to the toning process. Very gentle blue colors can be achieved by retarding the process. Otherwise the process is far too volatile and only very strident, almost electric blue colors are possible. This is a one shot solution and cannot be stored for future use, so weaker dilutions also make economic sense. Retain test strips as these can be used to test toning dilutions and color. They can test more than just exposure.

Selenium toner is a cumulative poison. Please wear rubber gloves, and only work in a well-ventilated area. Read and follow instructions carefully.

Getting it in

How do I get my image into my computer? I just don't understand it. A common cry. I feel another book coming on.

Let's look at digital cameras first. Whatever you buy now will be superseded by the same company within months. This is an extremely volatile market. In almost every digital publication is a whole new batch of sub £1000 digital cameras on review.

Do you really need one right now? Probably not. If you have the money they are a great deal of fun, great for simple family snapshots and images for web work. Estate agents (realtors to our American friends) taking snaps for their shop fronts and advertisements in the local newspaper could use these, easily justifying the costs. These small cameras are absolutely ideal for shooting simple setups to promote stuff over the internet.

Spencer Rowell, whose work appears in the 'Toning with curves' chapter, uses one for making digital copies of all his earlier folio prints and tearsheets of his work for his website. Spencer also uses it for shooting rough ideas when working out the logistics for bigger photographic shoots. No Polaroids, no film, or processing costs, and on his screen almost instantly. For most commissioned work Spencer sticks to his Hasselblads with medium format film.

There does seem to be an immense amount of research going on that leads to these little gems getting better all the time. For serious high-end photography they are simply not up to it yet.

At the other end of the scale there are extremely expensive digital backs for medium and large format cameras.

Last year during a lecture stint at a trade show, I saw a remarkable back from Lightphase for medium format cameras. It had single shot capture that was fantastic. Firewire technology will download the capture straight onto your Mac laptop or G4 computer. No download time is needed. Just straight into your system. It has a

small problem with artifacts being present in fussy areas like hair. For most repro this is more than acceptable. The real problem is that the chip is a smaller size than the normal 60 mm film size. The standard 80 mm lens behaves more like a short 120 mm telephoto. Camera positions would have to be changed if paranoia about digital capture required backing up with regular film.

This is an enormous sum of money to spend. Enough to buy a great deal of medium format camera equipment plus an extremely powerful computer. The film and processing costs can be passed to the client, as can the scanning costs.

At the moment of writing the future is bright on the quality capture front, but is not economically viable to most photographers. I am no doubt sure this will change in the near future. This technology is racing ahead at an enormous pace.

Commercial applications for the traditional darkroom are fast becoming redundant. Film on the other hand is not dead for a long time.

Film is still hard to beat. It is still relatively cheap. Quality, the great thing with film, still remains. A file that would give every piece of information that can be contained on a single frame of 35 mm film starts to get fairly large. Storage becomes a problem. At the moment a large number of megabytes would be needed for a file to have all the information of one roll of 35 mm film. Out-takes saved as film are less likely to be ditched. You can scan them and use them as components for images at any time.

Film can still be relied on to do what it has always done, and it still does it well. Stored carefully film is also remarkably archival. It can be scanned any time the image is required.

When I can get quality equivalent to 100 ISO film in my Nikon from a digital camera for roughly the same price, I will think of forsaking film.

OK, digital cameras have some applications and high-end digital backs come at a price. How do I get my image into my computer? With a scanner.

Understanding scanning technology is a book's worth on its own. I would recommend Agfa's *An Introduction to Digital Scanning* as a good starting point. The concepts of translating a physical object into digital information are not straightforward.

Scanners are divided into two basic types, drum scanners and flatbed scanners. Drum scanners will always give the best result.

Essentially drum scanners use a single beam of light fired through the transparency or negative for each pixel. This is captured by photomultiplier tubes (PMT) and converted to give information in the correct proportions for each of the Red, Green and Blue channels. This gives greater information for each pixel. As each pixel is captured separately, it is not only sharper but it also has a greater depth.

Flatbed scanners on the other hand use an array of charge-coupled devices (CCDs) essentially blasting the image to be captured with light as the CCDs move across the image. We are always going to encounter flare, which will degrade the image capture.

Fuji Velvia film has a density range of about 4.2, probably the widest range of most commonly used transparency films. The Hi Scan from Eurocore has a density

range of 4.6, enough to handle Fuji Velvia without information being lost at each end of the tonal range. I used Visualeyes Hi Scan for scanning most of the images I prepared for this book.

Most flatbed scanners have a typical density range of 3.6 to 3.8. Information in the highlight and shadows falls off the end. It will not be held. You are not getting the whole story.

The software that is used for premium capture is usually standalone and extremely sophisticated. A small image editing package in its own right. They usually enable a great deal of optimizing the image in terms of color control and unsharp masking on the fly as the image is scanned.

Most pre-press scanning is done on huge drum scanners. Crossfield and Linotype Hell are the better known big names. These come at premium prices upwards of £50 000. Definitely not for the home office. The previously mentioned Hi Scan uses the same PMTs as Crossfield mounted in a small desktop package for the small sum of £15 000.

The other downside of drum scanners is the transparencies and negatives have to be mounted individually on a drum. The transparencies have to be oiled beforehand to avoid Newton's rings and cleaned after scanning. A fiddly task, about the same difficulty of loading a medium format magazine for the first time. Not difficult but irritating nonetheless. On top of this the scan time is a great deal longer.

How many times have you seen this? 'Fantastic scanner deal comes with transparency hood, bundled with all this fabulous software will give you a maximum of 20 zillion pixels (interpolated) per inch. Only £549.99 plus local taxes. Ideal for the home office and small design company.' I've seen advertisements for home computers with scanners bundled with the deal showing quality 10" x 8" prints.

It is just not so. At best they will give an acceptable 6" x 4" print. They are fine for scanning your will and the deeds to your house. Cheap scanners are fine for rough layout. The bigger the object the better the scan. With 35 mm color negatives and transparencies, cheap scanners just won't cut it.

This is not to say that they are worthless. Far from it. The glass negative in the 'Repairing a glass negative' chapter was scanned on a flatbed scanner. Impossible to wrap it around a drum. I did scan it to give me a file that was twice the size required to give me an A3 print.

For most purposes a good flatbed scanner will give perfectly acceptable results for many uses, but will still cost a great deal of money. The CCDs that capture the information are not so very different between them. The software that controls the scanned information is where the real difference lies. You pay more for better software.

The final point worth noting is the pixels per inch (ppi) at which the scanner captures. Most flatbed scanners in the affordable range purport to offer a maximum pixel capture of 'up to 9000 ppi'. Reading the specification you will soon see that the optical resolution is probably no more than 1200 ppi. The 9000 ppi is usually

interpolated information, i.e. the information is invented in software NOT information captured from the scanned image.

There are a variety of 35 mm only scanners, Nikon, Minolta and Polaroid are the better known varieties. They operate on a similar principle to flatbed scanners, but are not asked to double up as A4 document scanners. They work extremely well provided you don't need to have images bigger than A4, or A3 at a pinch.

There is one oddity amongst all these, the Flex Tight Scanner, which mounts the transparency between two mounts so that it doesn't come in contact with any glass or a Perspex drum. The reports I have read say that it is better than a flatbed and is very close to drum scan quality. Worth checking if you can't quite afford a drum scanner.

Before parting with your hard earned on a scanner, check the specification. The internet is littered with websites for scanners. Most importantly, compare scanner results.

Weigh cost vs quality and so on. The quality you require and the budget you have are possibly different to mine. There is no 'it will do for now'. You have spent a lot of money on premium optics for your camera, as with enlarging lenses you don't want to waste all that with substandard scan quality. Don't believe all the 'snake oil' in the computer press. With scanners you really do get what you pay for.

A lot of superior bureau scans can be done for the same price as a scanner that will be superseded and out of warranty in twelve months.

File formats

I save all my images in one of five file types.

The first is **Photoshop**.

All my 'nearly' files are saved as the finished image in a full layered form with all the channels and paths left in tact. The files are always tagged with Nearly at the end, e.g. Tobi's Microlite Nearly, so that I know that they will open with everything that I need to re-edit and make color adjustments without starting from scratch.

The next is **TIFF** (Tagged Image File Format).

All final flattened images with all corrections, unsharp mask applied, finalized ready for saving as master files for output. All the Alpha channels are removed. Paths are left in if required for importing into QuarkXpress where the image might need cutting out.

All images are saved in Mac Byte order unless I am informed that the file needs to be read on a Windows machine.

LZW (Lempel-Ziv-Welch) compression is lossless. I prefer to leave it unchecked as it takes longer to decompress and open files. Some of my files are huge, often in excess of 175 Mb. If you have checked LZW compression, have no fear you won't lose information and with smaller files not a great deal of time.

The third option is **EPS** (Encapsulated PostScript).

This is used when I know that the output device uses a front-end PostScript RIP.

The Iris Inkjet and Novajet printers are examples of PostScript printers. PostScript RIPS are also available for Epson printers. These are extremely useful if you are printing proofs for repro. EPS is the preferred file format for most desktop publishing programs like QuarkXpress and PageMaker.

JPEG (Joint Photographic Experts Group) is the fourth option.

For sending a file over the internet purely for viewing JPEG is the quickest method. JPEG format compresses the file information so that it uses less space on your hard drive. Obviously a smaller file downloads over the internet much more quickly. Unfortunately, the more the image is compressed the more information is irreversibly lost. I only save final files as JPEGs to use as 'look-see' files.

Finally **PDF** (Portable Document Files).

I have downloaded from the internet many PDFs including an instruction manual for my Marshall guitar amplifier.

During the writing of this book I have saved the 28 Mb QuarkXpress file as a PDF and sent it from my home in Byron Bay, Australia, over the internet, to Marie Milmore at Focal Press in Oxford, for corrections. Acrobat Distiller compresses the file to about 7 Mb allowing it to be sent with ease, and opened on any computer platform, Mac or PC with Adobe's Acrobat Reader program. Relevant pages have also been forwarded to various photographers for their approval. PDFs are an efficient way to upload information for viewing. The latest version of Acrobat Reader is easily downloaded from Adobe's website.

These are the file formats that are in common use. There are loads more, usually for specific devices, but for now these will cover most of your needs.

While lecturing I ran a small slide show in the background as I spoke. The files were saved as **PICT** files and dropped into the slide show folder of the After Dark screensaver program. When the computer had been idle for more than five minutes the slide show quietly ticked away as I droned on.

Genuine Fractals is a curiosity that is available as a demo program with Photoshop. It saves a 25 Mb file compressed to a 5 Mb FIF file that can be decompressed and interpolated to over 200 Mb without appreciable loss. How good this is has yet to become established.

I know of a repro company in the north of England that uses this method for transporting large files over its ISDN line. How good this is I have yet to see. I do think that with cable television and the accompanying cable modems with transfer rates of up to 90 Mb per minute, this kind of compression and interpolation seem almost redundant before they have become established.

Getting started

As this book is a fairly personal approach to using Photoshop I will give you my own personal setup.

Even as I prepare this book the next generation of computers is constantly being announced in the press. Each generation, although not necessarily cheaper, is becoming more powerful. They seem to get faster and faster with bigger hard disks, and are capable of having more RAM loaded into them. Whether you are a Mac or PC devotee becomes increasingly less relevant.

I will not go into the merits of Firewire or USB and so on. By the time you read this, the exciting generation of new devices will be bigger, faster, cheaper than the 'hot' new products that I wish my bank manager would see reason on today.

Your computer and Photoshop

When it comes to the 'tech' bit I still find that I refer to Martin Evening's *Adobe Photoshop 5.5 for Photographers* book to find out what my machine is actually doing while I work. I read it so that I can appreciate what goes on, and, having a rough idea of the mechanics of my machine, I can aim to get better performance from it. I don't understand fuel injection but it doesn't stop me driving.

The basic rule of thumb is: there is no such thing as too much RAM.

Photoshop, as indeed is most imaging software, is memory hungry. While preparing this book I've allocated enough RAM to QuarkXpress and enough to Photoshop so that I can work with both open and toggle between each.

So be aware that the RAM supplied with your computer when purchased will probably not be enough. If you are serious about Photoshop, I recommend that, after system requirements, at least 100 Mb of RAM be allocated to Photoshop, and also remember to leave enough to drive your printer.

If you are limited in this department allocate as much as possible. Be aware though that annoying progress bars will appear more regularly and seem to take forever to move. This is the digital equivalent of rocking your tray full of developer in the darkroom. Basically you need as much RAM as possible, most of which you should allocate to Photoshop. If possible work with Photoshop as the only program open.

The other rule of thumb is: there is no such thing as enough Scratch disk. So have as big a hard drive as possible. If you have outboard storage, Zip, Jaz and an extra hard drive or DVD RAM, up to four devices can be allocated as Scratch disks in the Photoshop Preferences Panel.

The best performance can be achieved if you can allocate a non-system disk as your primary Scratch disk. Note also the faster the read/write time of your disk the faster your Scratch disk performance.

As you progress with work on an image the Scratch disk fills and the computer will slow down. With the introduction of Photoshop 5.0 Adobe brought in the facility to purge the Scratch disk. Before you purge your Scratch disk willy nilly remember that you can no longer reverse through your History pallet should you choose to purge this as well. It has gone!

A brief word about monitors

The next main item is your monitor and video cards. Big is beautiful! As big as you can get. Have two if you can, one to put your pallets on, and one purely for your image and the tool you are using, i.e. brushes. I have found that working in thousands of colors lets the monitor redraw run a little faster, and I find that I am a little less disappointed when sending a file for printing on watercolor papers. A good monitor is expensive, although as with all digital technology the price is coming down all the time. It is certainly worth shopping around. This is how you are going to view your image for the next few years.

Remember that the transmitted light from your monitor is not the same gamma as ink on any printed material. For this reason I am not a big fan of art directors looking at huge transparencies on light boxes and everybody wondering what happened when the image is reproduced in a magazine. An image with transmitted light will always look more contrasty and have a lot more 'zing', for want of a technical word, than the same image viewed in the CMYK color space reflected from paper.

For Photoshop work you don't need lots of bells and whistles on your computer. What you do need is as powerful a CPU as possible, as much RAM as possible, as much storage as possible, and as good a monitor and video card as possible. As with all purchases your other computing needs and your ability to finance it will obviously be a factor. A free joystick, three shoot 'em up games, slightly suspect voice recognition and a 1985 encyclopedia on floppy disk will not enhance your work in Photoshop.

Setting up your system for Photoshop

Memory Control Panel

First, for Mac users go to Control Panels and check the virtual memory button to Off. You will need to reboot your computer for this to take effect. I am reliably informed that Photoshop prefers your system working this way.

Preferences

File > Preferences > General
I prefer leaving everything pretty much at the default settings.

Display & Cursors. I set to Brush Size and Precise. You cannot work accurately with any of the brushes if the brush icon is displayed and is not the shape you need to work with. That this is even an option is a mystery to me.

Monitor calibration

This is most important. If you don't have an expensive profiling calibrator and software, use the Adobe Gamma Control Panel. It is the same Control Panel for Windows and Mac.

When calibrating, I turn screensavers and computer sleep modes off. Leave your monitor switched on for half an hour to thoroughly warm up.

I have a LaCie Blue monitor as the dark blue casing allows me to concentrate on the screen, with a slip-on hood shielding unwanted light from the screen. This is not an endorsement, just a personal preference that also fitted my budget.

Unfortunately, the more recent Mac desktop settings, although a lot of fun, are not really appropriate for working with images when the color of Bondi Ripple with Flying Saucers interferes with adjusting color in Photoshop.

To overcome this I made a small neutral gray picture in Photoshop.

Open a new image: File > Open [Command/N], it only needs to be small, 5 inches square with a 72 ppi (pixels per inch) is ample. Fill the empty space: Edit > Fill to Black set to 18% in the Fill dialog.

Flatten the image: Layer > Flatten, and save to the desktop Images folder.

The new file can be opened and tiled to fill the screen with the Appearance Control Panel. It might not be the most exciting of desktops but there is less chance of conflict with color correction by using a neutral background.

Follow the Adobe Gamma Control Panel carefully.

I usually save the Gamma Setting as Max's followed by the date, e.g. Max's 17/12/99. It stands out in any profile list next to all the other Gammas.

Before Photoshop 5.0 I would have created a separate Gamma for each output device used, especially with the Iris printer at Visualeyes. Simon Perfect, who managed the Iris, was using an early version of Lyson's Permanent inks. These inks inhabited an unusual color space, so matching the image on screen was quite a process.

Color Settings

File > Color Settings > RGB Setup

I set the RGB to Adobe RGB (1998). I also check Display Using Monitor Compensation as I feel this is going to give me all the possible color that my monitor can allow.

```
┌─────────────────── RGB Setup ───────────────────┐
│                                                  │
│   ┌ RGB: Adobe RGB (1998)    ▲▼ ┐      ┌──────┐ │
│   │                                │    │  OK   │ │
│   │   Gamma: 2.20                  │    └──────┘ │
│   │                                │    ┌──────┐ │
│   │   White Point: 9300°K     ▲▼   │    │Cancel│ │
│   │                                │    └──────┘ │
│   │   Primaries: Adobe RGB (1998) ▲▼│   ┌──────┐ │
│   └────────────────────────────────┘    │Load… │ │
│                                          └──────┘ │
│   ┌ Monitor: 17/12/99                    ┌──────┐ │
│   │                                      │Save… │ │
│   │  ☑ Display Using Monitor Compensation└──────┘ │
│   └──────────────────────────────   ☑ Preview    │
└──────────────────────────────────────────────────┘
```

File > Color Settings > CMYK Setup

In this box I check the ICC button. Profile is set to Generic CMYK Profile. This is not a permanent setting. It is changed depending on what materials I am printing on with my Epson printer. This is purely for printing at home.

```
┌─────────────────── CMYK Setup ───────────────────┐
│                                                   │
│  CMYK Model: ○ Built-in ● ICC ○ Tables   ┌──────┐ │
│  ┌ ICC Options ─────────────────────┐    │  OK  │ │
│  │ Profile: Generic CMYK Profile ▲▼ │    └──────┘ │
│  │                                  │    ┌──────┐ │
│  │ Engine: Built-in    ▲▼           │    │Cancel│ │
│  │                                  │    └──────┘ │
│  │ Intent: Perceptual (Images) ▲▼   │    ┌──────┐ │
│  │                                  │    │Load… │ │
│  │     ☑ Black Point Compensation   │    └──────┘ │
│  └──────────────────────────────────┘    ┌──────┐ │
│                                           │Save… │ │
│                                           └──────┘ │
│                                          ☑ Preview │
└───────────────────────────────────────────────────┘
```

File > Color Settings > Grayscale Setup

As all my output goes to some form of color-based output I set this to RGB, as I don't normally need to worry about Dot Gain for Grayscale usage.

```
┌────────── Grayscale Setup ──────────┐
│                                      │
│   ┌ Grayscale Behavior ┐  ┌──────┐  │
│   │                     │  │  OK  │  │
│   │   ● RGB             │  └──────┘  │
│   │   ○ Black Ink       │  ┌──────┐  │
│   │                     │  │Cancel│  │
│   └─────────────────────┘  └──────┘  │
│                            ☑ Preview │
└──────────────────────────────────────┘
```

File > Color Settings > Profile Setup
These are all set to Ask When Opening. Embed Profiles buttons are all checked. This allows a choice when opening files.

When supplying files to a bureau, I would always send my files as RGB files and make sure that my multi-layered file with Adjustment Layers was available in case I felt that elements might need to be 'tickled' to suit the output.

Essentially, while I worked from Visualeyes I would trust Simon Perfect to do the CMYK conversion to suit his Iris setup. Visualeyes run test patches from their various output devices. These are then measured on an extremely expensive spectrophotometer to then set up a CMYK profile for that particular machine, with that particular ink set on a particular substrate (paper), e.g. an Iris printer, with Lysonic Permanent inks, on Somerset watercolor paper. A print from a Novajet printer, with Equipoise ink on a Glossy photo style paper, would require a totally different CMYK conversion.

Likewise, an image reproduced in a coffee table book will require a different conversion to the same image reproduced in a newspaper color supplement. A fine example of reproduction is the beautiful monograph *Cyclops* by the American-based photographer Albert Watson. Another lovely example is *Passages,* a retrospective of Irving Penn's huge body of work.

Richard Benson, who was responsible for the production of the *Cyclops* separations, and was a consultant during the production of the Irving Penn volume, is a fascinating man with an enormous wealth of knowledge about the printed page. A conversation with Richard is always illuminating when the topic is about the nature of ink, paper and the printing press.

As I stated in the introduction, a large percentage of my work has ended up as ink somewhere. This is a huge topic, which could occupy volumes. One should become aware of the mechanics of repro if your work is heading in that direction.

Given Photoshop's early tendency to be geared to pre-press, I have found increasing involvement with the gap between processing the film and the point at which ink ends up on a page.

Photographic printing and reprographic printing have rarely cohabited comfortably. Photoshop has narrowed the gap between both these disciplines. As a matter of necessity I firmly believe that photographers, photographic post production (printers and retouchers), designers and pre-press operators overlap more than ever.

Although this has little to do with creativity it has a great bearing on whether your creativity is wasted at the final output stage.

This is not a breakdown of the ins and outs of computer hardware or comparative software but a guide to making pictures. This setting-up chapter is to get you going.

Tools and stuff

Most books about Photoshop include a chapter about all the tools and all the keystrokes. I'll keep mine as brief as possible. The toolbox is your second best friend. Your imagination remains your first best friend.

Most of the icons in the toolbox are fairly self-explanatory. Once familiar with these tools and their settings the whole of computer imaging becomes more accessible. Most software packages have a toolbox that uses similar tools in a similar way to Photoshop.

Adobe supplies a quick reference card that is really useful. Along with Martin Evening's book *Adobe Photoshop 5.5 for Photographers* and an old *Photoshop 4 Bible*, it sits within arm's reach whenever I work. No matter how many hours one sits working with this program someone else will always have a tip or method which will work faster or achieve the result more accurately than the method I know.

My methods are long hand, trying not to rely on the software assuming too much control. I don't use many filters either, or get too bogged down with every keystroke. We are after all making pictures, not playing in a band.

In the darkroom I always used a fairly standard developer, stop bath and fix setup. Basic sepia, selenium and blue were the toners most used. Tricks were always kept to a minimum. I am the same with software.

I have a lot of plug-in filters but they are rarely used. If they do something that you find useful, feel free to try them. I am not a purist either. After all this time I usually know what I want but always try to remain open to new ideas. If we didn't, we would still be using clubs instead of computers.

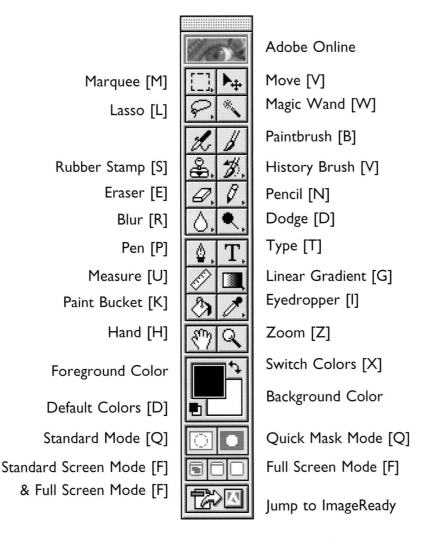

	Adobe Online
Marquee [M]	Move [V]
Lasso [L]	Magic Wand [W]
	Paintbrush [B]
Rubber Stamp [S]	History Brush [V]
Eraser [E]	Pencil [N]
Blur [R]	Dodge [D]
Pen [P]	Type [T]
Measure [U]	Linear Gradient [G]
Paint Bucket [K]	Eyedropper [I]
Hand [H]	Zoom [Z]
Foreground Color	Switch Colors [X]
Default Colors [D]	Background Color
Standard Mode [Q]	Quick Mask Mode [Q]
Standard Screen Mode [F]	Full Screen Mode [F]
& Full Screen Mode [F]	Jump to ImageReady

The toolbox with shortcut key [in brackets] to select tool.

Double click on tool or press Return to access tool option box.

Chapters of some length have been filled in many manuals about tools and their settings. When first starting with Photoshop experiment with settings to find out what is happening. Find out first hand what all these tools do.

Marquee [M]
Elliptical Marquee
Single Row Marquee
Single Column Marquee
Crop (C)

Lasso [L]
Polygon Lasso
Magnetic Lasso

Rubber Stamp [S]
Pattern Stamp

Eraser [E]
Background Eraser
Magic Eraser

Blur [R]
Sharpen
Smudge

Pen [P]
Magnetic Pen
Freeform Pen
Add-anchor-point
Delete-anchor-point
Direct Selection
Convert-anchor-point

History Brush [V]
Art History Brush

Pencil [N]
Line

Dodge [O]
Burn
Sponge

Type [T]
Type Mask
Vertical Type
Vertical Type Mask

Linear Gradient [G]
Radial Gradient
Angle Gradient
Reflected Gradient
Diamond Gradient

Eyedropper [I]
Color Sampler

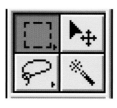

Drop-down tools all have a small arrow in the lower right-hand corner.

26

These are the tools explained, perhaps not fully but enough for their usage within this text. They will appear again within the context of the method being described. As with most methods in this book I am trying to give ideas that can be taken further. No method is absolutely the only way to achieve anything. All creative ideas are about finding something out and then putting your own stamp on it.

As stated in the Introduction, this is not specifically a Photoshop book but a source book for darkroom emulation using Photoshop instead of chemicals. Although not an exhaustive description it is enough to get you going.

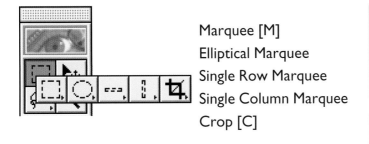

Marquee [M]

Elliptical Marquee

Single Row Marquee

Single Column Marquee

Crop [C]

The Marquee tools are used to make selections by dragging over the selection area. Hold the Shift key to add to a selection while dragging again. Delete from a selection by holding the Alt/Option key while dragging. Flashing dashes often referred to as 'marching ants' indicate the selection. Hide marching ants: View > Hide Edges [Command/H].

The selection only, not its contents, can be moved by placing the cursor inside the selection and dragging, or use the arrow Cursor keys to move the selection one pixel at a time. Holding the Shift key while using the Cursor keys moves the selection ten pixels each time the key is pressed.

The Crop tool does exactly that. Fixed size cropping with a file resolution can be entered in the Crop options box. Crops can be rotated by the corner when the small arrows, similar to the switch colors, appear. Holding the Command key while cropping close to the edges of images allows the crop line to be moved smoothly. Otherwise it will often jump to the edge of the image. I don't remember this happening in earlier versions of Photoshop, but it does now and it is irritating.

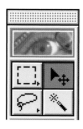

Move [V]

The Move tool can be used to drag and drop layers and selections from one image to another.

Move selections or whole images from Photoshop to another application, i.e. Illustrator.

Move selection contents or layer contents within a layer.

Copy and move a selection by holding down Option/Alt key.

The moves can be dragged with the cursor or with the Cursor keys one pixel at a time.

The ten pixel move with the Shift key works here as well.

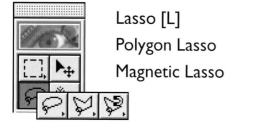

Lasso [L]

Polygon Lasso

Magnetic Lasso

The Lasso tools work in a similar way to the Marquee tools. The freeform Lasso tool is used to make selections by dragging around the selection area while holding down the mouse button. Releasing the mouse will join the first and last end points.

The Polygonal Lasso draws straight lines between points created when the mouse is clicked where you want the next line to begin. Clicking over the end point will join the selection. Double clicking the mouse will join the beginning and end points if you can't find the beginning. (It does happen.) The delete key undoes the previous fixed point. Repeated deletes will undo more fixed points.

The Magnetic Lasso is a great method of achieving selections. It senses an edge based on contrast – set in the options box – and clings to it. Used with a graphics tablet the settings can be varied with stylus pressure. I use it to get approximate selections and then clean them up in Quick Mask.

Magic Wand [W]

The Magic Wand at first seems fairly useful. I now find that I hardly use it except when selecting areas of a single color. I have found color range, although initially with more effort, a far more useful and controllable method of selection. Color range is explored more fully later on.

Airbrush [J]

The Airbrush behaves like an airbrush. Holding the mouse button causes the brush to continue spreading paint as a real airbrush would. Densities can be varied with the slider in the options box. If you become adept with a graphics tablet the brush tools behave very much like real brushes. Brush sizes are selected from the brushes pallet.

Paintbrush [B]

The Paintbrush closely resembles its namesake, right down to setting it to have wet edges and fade as it paints. It is extremely useful for editing Alpha channel selections. Toggling between foreground and background colors from the toolbox or using the X key allows filling or erasing. This also applies to Quick Mask editing. Use the Alt/Option key to sample colors while painting. The Paintbrush is an extremely useful tool for retouching and selection editing.

Rubber Stamp [S]
Pattern Stamp

The Rubber Stamp, or 'clone' tool, is one of the most used tools. It is absolutely essential for retouching small blemishes. I once heard it referred to as a 'zit zapper', a totally appropriate title. This tool is explored more fully in the 'Retouching' chapter later on.

I must admit that I haven't yet found a use for the Pattern Stamp. In time I am sure I will.

History Brush [V]
Art History Brush

The History Brush, one of the big innovations in Photoshop 5.0, initially appears as the long awaited multiple undo. It is far subtler. Apart from being able to cycle through various stages in the image editing, its use as a retouching tool is explored in the 'Restoring an old negative' chapter.

A maximum of 100 histories is allowed. A non-linear history can be set from the history options toggled from the drop-down menu on the right of the history pallet.

Non-linear history allows cycling back to a previous state and then exploring another option without

disturbing the version that has taken arduous editing. The new variations are dropped on the bottom of the pallet. Cycling through the history pallet can make comparisons between various previous versions. I often go back to a previous history state, make a duplicate: Image > Duplicate and use that with its own 100 non-linear history states. This is a major item.

The Art History Brush makes impersonations of impressionist brush strokes. After five minutes of playing tedium set in. Not for me.

Eraser [E]

Background Eraser

Magic Eraser

The Eraser erases, leaving the background color displayed in the toolbox. All the brush sizes and options available to other brushes are available to the eraser, which is essentially a brush. It also has the block option, a hard edged square. The eraser can be used in the same way as the Paintbrush tool when editing Alpha channel selections and Quick Mask.

By checking Erase to History in the options box, the Eraser can erase to a past point in the History pallet – a reversal of the Dust & Scratches/History Brush technique explained in the 'Restoring an old print' chapter.

Photoshop 5.5 has introduced the Background Eraser, which is used with: Image > Extract [Command/Option-Alt/X]. A dialog opens rather like some of the third-party plug-in filters where the foreground can be extracted from the background. So far it works fine when the demarcation between the background and foreground is obvious but runs into trouble when the difference is not quite so defined. The tolerance settings aren't precise enough for the selections I use. It could be used for making basic selections for editing more precisely later.

I haven't found any of the masking plug-in filters or the Background Eraser as controllable at making selections as the numerous ways explained further on.

The Magic Eraser seems to be geared for use with limited color images used for web display. I am sure that this tool will have a great deal of use with those optimizing images for web display – especially with the new ImageReady that now comes bundled as a plug-in, web-based imaging program with Photoshop 5.5.

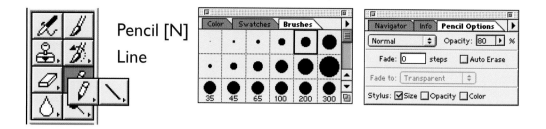

Pencil [N]

Line

The Pencil tool draws a hard edged line. The brush size can be altered but the line remains hard edged. For the work that I have done so far I don't have a particular use for the Pencil. I found that my drawing in art classes was acceptable but I was sure glad when I discovered cameras.

The Line tool draws straight lines. You can vary the width and put arrowheads on the end. Jon Bader could have used this to put the wires back in the bridge in the 'Absolut Anzac' chapter. Along with the Pencil, this is not a tool for which I have a use. Designers using both Illustrator and Photoshop would possibly find a good use for these more painterly tools.

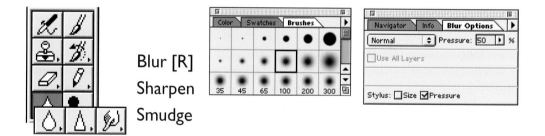

Blur [R]

Sharpen

Smudge

The Blur tool is handy for softening small localized areas or for softening edges of selections where elements have been comped together. Slightly softened edges using the feather command: Select > Feather [Command/Alt/D] with a setting of between 0.2 and 0.5 pixels usually does the trick without laboriously using the Blur tool.

I don't like this tool at all. Making small selections and using Unsharp Mask is a far superior method of sharpening. Overindulgence with the Sharpen tool leaves nasty artifacts. Both of these tools are best used at low settings.

The Smudge tool could be used to emulate distressed Polaroid. Again these tools are not items I particularly use.

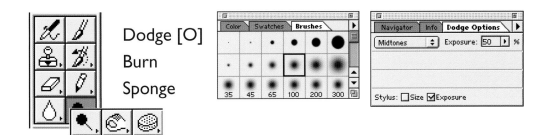

This last group of brush-based tools has a real use. I remember bewailing to Adobe's Russell Brown during my informative sojourn in America that early Photoshop had no real darkroom tools. I was delighted to find that by the time I had managed to get a share in a Mac that Photoshop 3.0 seemed much more of a program that photographers could really use.

The Dodge tool lightens while the Burn tool darkens, similar to their darkroom counterparts. These can be applied to the highlight, mid-tone and shadows separately. The Sponge tool can be set to saturate or desaturate. For the original of Bob Carlos Clarke's image of Hermione with the antelope horns, I used the Sponge tool to saturate the model. During the reconstruction for the book I simply made a selection and used curves. The hue and saturate dialog could be used in a similar way.

Many darkroom printers often use a brush or cotton wool dipped in Farmers Reducer to bleach small areas of prints, the whites of eyes being a particular favorite. The Dodge tool is ideal for this kind of thing.

While using any of these tools it is advised also to load up a new view: View > New View to keep a check of what is happening to the image overall while working with a zoomed section of the file. Sometimes it is difficult to see what is happening to the whole picture with the zoomed view. The new view is not a duplicate but the same picture displayed at the same time in a separate window.

As with the previous set of tools, low settings and gentle use will yield the best results. With care these are very useful tools.

Pen [P]

Magnetic Pen

Freeform Pen

Add-anchor-point

Delete-anchor-point

Direct Selection

Convert-anchor-point

The Pen tools, as with the Marquee and Lasso tools, are methods of making selections. Jon Bader, whose images in the 'Tattoo' and 'Absolut Anzac' chapters, uses the Pen tools to make and save his selections. Once saved as paths he then converts them to more normal selections and manipulates from there.

Unless the image needs cutting out and dropping into a layout program like Illustrator, QuarkXPress, or Adobe's new InDesign, I rarely use paths. I prefer to make selections and save them as paths if paths are required.

These tools are not being dismissed. They certainly have very definite uses. The Bézier curves created with Pen tools are absolutely fabulous for cutting out cars, jet skis and many other objects in product-based photography. This is a Photoshop discipline and to deal with it comprehensively requires some 50 pages on its own.

Type [T]

Type Mask

Vertical Type

Vertical Type Mask

The Type tool is now quite a big tool in Photoshop. Perhaps the idea of taking files prepared in one of the Adobe programs to another, e.g. Illustrator to Photoshop to InDesign and so on, has forced this tool to be taken more seriously. Once entered into a layer and rendered, all sorts of filters and layer effects can be messed around with. This book is not about typography but I have had a lot of fun playing with it.

Measure [U]

Measure is used to measure things, like distances and angles, and I have never used it. I am sure that, along with some of the other tools, this one is geared to designers.

Linear Gradient [G]
Radial Gradient

Angle Gradient

Reflected Gradient

Diamond Gradient

I do not have a darkroom-based use for the last four of these tools as I find them a bit 'gee whiz', but the linear gradient is extremely useful as explained in the 'Gradient' chapter. I have repaired many skies in my old transparencies that had been consigned to the box at the bottom of the filing cabinet.

With a little lateral thought, graduated neutral density filters could be emulated as well as the graduated tobacco filters of old. Gradients have a potential to banding so should be applied with care.

Paint Bucket [K]

The Paint Bucket tool fills a selection with the foreground color, or fills an area based on the Tolerances set in the options box, similar to the way the Magic Wand makes a selection. I prefer to fill areas with the fill command: Edit > Fill, and then make choices from the Fill dialog box. Maybe slightly longer, but it gives more control. The Paint Bucket is too automatic for me.

Eyedropper [I]

Color Sampler

The Eyedropper tool is useful for sampling a color set as the foreground color when using the paint tools, or for sampling a color when filling a selection or empty layer.

The Eyedropper tool becomes the default tool when the Curves dialog is open. Clicking on any point while the Curves dialog is open shows the point along the curve where that tonal value sits. Great for finding out where to push and pull curves to adjust images.

The Color Sampler allows points to be sampled to give numeric feedback when color correcting images. The sample area can be adjusted from a single point, 3 × 3 average, or 5 × 5 average in the options box.

Hand [H]

The Hand tool is for navigating around the image when it is zoomed larger than screen size. Holding the spacebar toggles all brush and editing tools to the Hand tool to enable the same navigation. Be careful to hold the spacebar down while dragging around the image with the mouse or you might find that you have unwittingly cloned or painted a great line across the image. Not that it cannot be undone, but is irritating nonetheless.

Zoom [Z]

The Zoom tool increases the magnification. Dragging over an area with the mouse magnifies that area. Holding the Alt/Option key while clicking will zoom out. Double clicking on the Zoom tool icon will automatically zoom the image to 100%. The Command key with the plus or minus keys will zoom in or out as well. Command 0 (zero) will zoom the image in or out to fill the screen inside the pallets.

 Foreground Color
Background Color
Default Colors [D]
Switch Colors [X]

This displays Foreground Color – left-hand side – and the Background Color – right-hand side – black and white by default. These are changed by double clicking on either which brings up the Color Picker dialog. Foreground and Background are switched with the little arrow in the color box or can be toggled from one to the other with the X key. Toggling with the X key is extremely useful when editing an Alpha channel or editing with Quick Mask.

 Standard Mode [Q]
Quick Mask Mode [Q]

Standard Mode displays the image with any selection appearing with 'marching ants'. Toggling to Quick Mask displays the selection as clear with a red mask at 50% opacity. Quick Mask can be edited with any of the brush tools. Quick Mask can also be edited with Marquee and Lasso tools used to select and delete or fill. Toggling back to Standard Mode will display the selection with marching ants where it can be saved or edited. A major tool when making and editing selections.

 Standard Screen Mode [F]
Full Screen Mode – Gray [F]
Full Screen Mode – Black [F]

Standard Screen Mode displays your normal desktop with image, any toolbox pallets that are in use, icons, launcher window and menu bar. Toggling with the F key or clicking on the center box will display a gray desktop with only the image open and any Photoshop tools that are in use. The final box or F key again will give them the same display with a black desktop. The pallets and toolbox can be removed from the display with the Tab key. Shift/Tab will remove all the pallets and display the toolbox. A useful item for displaying your image without desktop clutter.

Jump to ImageReady

The final item in the toolbox opens Adobe ImageReady. This is Adobe's new web optimizing program that prepares images for use on websites. This now comes bundled with Adobe Photoshop 5.5.

ImageReady allows files to be edited with Photoshop's massive array of editing tools and then prepared for internet distribution. I haven't even had the chance to look at this program yet.

Fortunately my agents Tanya Carter and Norma Walton take care of my web presence. I am certain that in time, anybody acknowledging the massive global interest in the internet will investigate the potential of the power of Photoshop coupled with this program.

These are the tools in a basic form. Experiment, play and become familiar with them. These are the spanners, saws and hammers of Photoshop.

Throughout this book all commands will be indicated after a colon by the menu – top of the screen – followed by the menu selection, then followed by any submenu selection. The keystroke equivalent will follow in squared brackets, e.g. Create an empty layer: Layer > New > Layer [Command/Shift/N]. I have put Command first as that is where I place my thumb before the Shift/N keystrokes, a bit like guitar chords. Maybe we *are* in a band.

Note. In most software packages these days the common keystrokes are displayed on the right-hand side of the drop-down menus. If one were to scan every manual and imaging publication a whole book's worth of keystrokes could be found. I use quite a few but tend to absorb them as needed rather than make an all-out effort to become a keystroke wizard.

I've left the pallet descriptions to occur within the context of each technique. I hope this 'context' method will illustrate their importance. I also have not described every minor item, I hope your own sense of inquiry and adventure will ensure your desire to make this program your own.

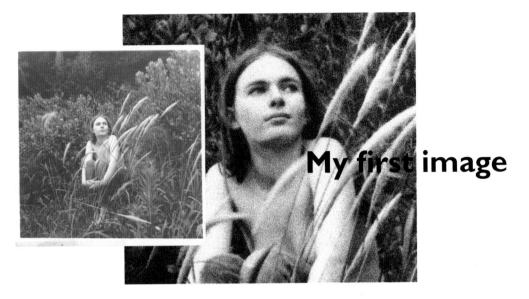

My first image

It seems appropriate that the first image that I visit for digital treatment should be my first serious attempt at photography.

It was early summer in Sydney. Susan, the young girl pictured, had lent me her father's old Rolliecord. Snap. Unknown to me at the time, this was the beginning of my career.

While this was being displayed on the monitor I was told that it was reminiscent of the well-known Cottingly Fairy pictures, made infamous by Sir Arthur Conan Doyle. With this in mind I thought of treating it like an old platinum print, with inkjet on watercolor paper as the chosen output.

Unfortunately the only print in existence is a thirty-year-old fairly battered enprint. Quite an amount of work would be required to disguise the lack of quality. Also, my lack of photographic technique at the age of sixteen has given me a nasty leaf across the chin to retouch.

I began with a high resolution drum scan set to give me an image size of 13" × 13", enough to allow for cropping, and still fill an A3 print.

With monochrome images I prefer to start with files that are slightly on the flat side. I prefer my black and white negatives the same, with detail in the shadow and highlight areas. As with split grade printing on multigrade papers, Photoshop allows an increase of contrast. It is easier for detail to be taken away than to be put back.

If you were to go via the traditional darkroom, this would be sepia toning a black and white print made from a copy negative.

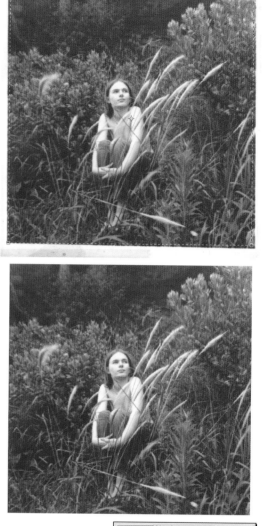

The scan from the enprint was set to give a grayscale file large enough to allow a print 13" × 13" after cropping. A 20 Mb file was ample.

Double clicking the Crop tool opens the Crop Options box. Check Fixed Target Size and enter 13" × 13". Entering 300 pixels per inch (ppi) will give a final image size at the correct resolution for 1 to 1 output for press use and output for the Iris printer without any interpolation. The file is now 14.6 Mb. **Note.** the Crop symbol looks like a pair of L cards used to lay over contact prints.

As the original image was not of a particularly high quality, a small amount of Unsharp Mask was added at an early stage to increase definition.

With sophisticated scanning software Unsharp Mask can be introduced at the scanning stage.

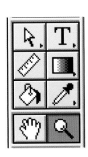

The Zoom tool allows the image to be increased in size. Holding the Option/Alt key with the Zoom tool allows the image to be decreased in size. Use the keystroke [Command/+ or –] to increase or decrease in 12.5% increments. **Note.** I advise retouching to be done at 100% where every pixel on the screen is an actual pixel of the file. While working close up on a small area of an image the global effect can be seen by selecting: View > New View. Another window opens whereby the file can be viewed at a smaller size on the screen. This is not a separate file but an extra window.

To retouch into an empty layer without disturbing the background file until retouching is complete, make a new layer: Layer > New > Layer [Shift/Command/N] or the same command from the flyaway menu top right of the Layers pallet.

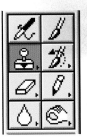

The Rubber Stamp tool 'clones' pixels sampled from one part of an image (Source) to another (Target).

Holding the Alt/Option key while clicking the mouse key sets the Source, releasing the Alt/Option key and clicking the mouse again sets the Target. Align checked Clone Options. Clone opacity can be varied with opacity slider.

Some of the areas are difficult to find a suitable clone source in, so a paintbrush is used to paint over the mark on the face. Holding the Alt/Option key while clicking the mouse near the area to be painted samples a foreground color to paint with.

A soft edged brush is best in this situation. The foreground needs to be constantly re-sourced to make the colors match the background. The same can be done with a Wacom Tablet and stylus, Option plus Stylus pressure release and repeat pressure. Graphics tablets are an ideal way of editing with any of the brush-based tools, emulating real brush in a much freer way than using a mouse.

To smooth the brush strokes a small amount of Gaussian Blur: Filter > Blur > Gaussian Blur is added to the painted layer.

A smooth painted layer would stand out against the background layer.

A small amount of Noise: Filter > Noise > Add Noise was added to give the feeling of film grain.

Blend by reducing opacity in painted layer. Flatten Layers: Layers > Flatten Layers.

To increase your exposure duplicate layer: Layer > Duplicate. Check Multiply in drop-down menu.

The opacity slider can be used to reduce the amount of Multiply.

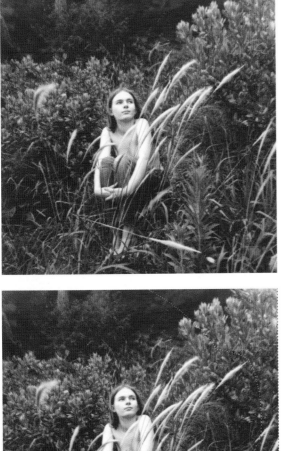

Multiplying the duplicate layer is similar to doubling your exposure. Shifting the opacity reduces the amount of extra exposure.

A freeform selection is made with the Lasso tool. Lasso Options is set to 0 pixel feather.

Holding the Shift key allows you to add to the selection by dragging the cursor over the area to be added. Holding the Alt/Option key allows you to delete from a selection while dragging the cursor.

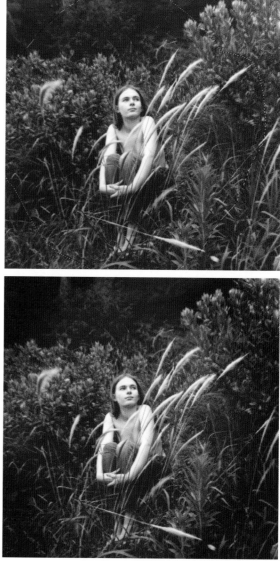

Feather Selection: Select > Feather [Alt/Option/ Command/D]. Type in the amount of Feather required. The larger the pixel number for feathering, the more gradation between selection and background.

This is similar to burning the edges of a print with a hand or piece of card under the lens.

Make an Adjustment Layer: Layer > New > Adjustment Layer. Check Curves in Adjustment Layer dialog box.

The Adjustment Layer now includes a Layer Mask.

The layer stack now needs to be flattened. Flatten Image: Layers > Flatten Layers.

To disguise retouching and the poor quality of the original add a duplicate background layer: Layer > Duplicate.

Then add Noise: Filter > Noise > Add Noise. By using more Noise than required will allow a mix of Noise Layer and Background Layer. The mix can be varied with the Layer opacity slider.

To introduce a tone, in this case a gentle sepia, make the image color: Mode > Image > RGB. The image now has three channels and a file size of over 43 Mb.

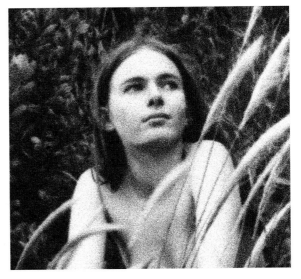

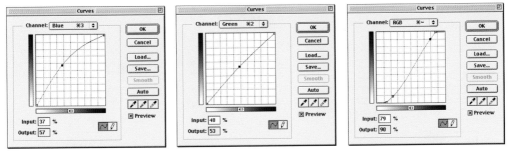

The sepia tone is introduced with an Adjustment Layer: Layer > New > Adjustment Layer. Check Curves in the Adjustment Layer drop-down menu. The RGB drop-down menu is used to adjust each channel. The Yellow channel is often too green. A little magenta will remove the green cast. Contrast can be increased in the RGB channel. The 'Toning with curves' chapter takes the idea of Photoshop emulating chemical toners much further. Double clicking the Adjustment Layer brings up the Curves dialog box. Curves can then be altered at a later date if required.

Opening ⬍	🖿 PowerMAX
📄 Sue Dedication Page	Eject
📄 Sue Dedication Page.RGB eps	Desktop
📄 Sue Scan	New 📁

Save this document as:

Sue Nearly

Format: Photoshop ⬍

Cancel / Save

Opening ⬍	🖿 PowerMAX
📄 Sue Dedication Page	Eject
📄 Sue Dedication Page.RGB eps	Desktop
📄 Sue Nearly	New 📁
📄 Sue Scan	

Save this document as:

Sue Final (proof)

Format: Photoshop ⬍

Cancel / Save

I usually save in layered form as file name Nearly, e.g. Sue Nearly. This can be opened again and adjusted without having to alter pixels until the image is collapsed: Layers > Flatten Layers, and saved for proofing.

Tools used

Crop tool
Zoom tool
Mode Change – RGB
Add Layer
Rubber Stamp (Clone)
Paintbrush
Noise filter
Duplicate Layer
Mode Change – RGB
Adjustment Layer
Curves

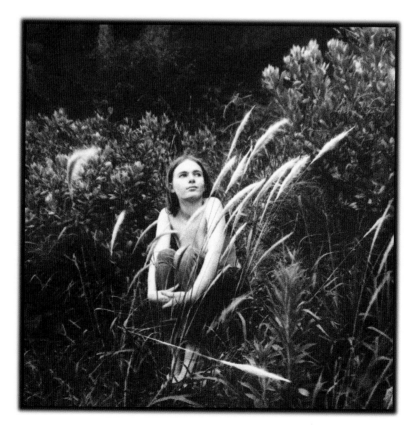

Digital darkroom basics

The previous chapter is an example of how to make a copy negative, i.e. scanning the image, then making a retouched platinum print, with an introduced mezzo dot.

I used to make an exposure through a mezzotint screen, purchased for about £200 in 1988, from a reprographic company. These screens are used to introduce a random dot when making plates for repro. A modern variation, stochastic screening, is used to emulate film grain in reproduction. In the earlier mentioned Albert Watson book *Cyclops*, this method is used for the production of the plates for the many fine images.

Making an exposure with the screen over the paper would also introduce a dot to break up the image. It was a great way of introducing grain to a print from a large format negative. Fantastic quality and detail, often lost with 35 mm, could be maintained by using a large negative. With the screen, the image could be made to emulate 6 × 6 cm or 35 mm film stock. Unless used judiciously, it could often look mechanical.

These screens were often used to make large format lith negatives, often called tone dropouts, with grain. The first one I saw being made was to become the inside cover of Elton John's *Honky Château* LP. Although someone else had prepared the negative, I was invited to print it as my first lesson in the darkroom.

These treatments were very popular in the early 1970s, Led Zeppelin's first LP cover being probably the best known. Alas not my work.

This chapter introduces some of the methods for emulating darkroom techniques with Photoshop. Primarily this chapter deals with digital exposure and grade.

This picture was originally shot with a large format camera to retain the quality in shadows and highlights alike.

A scan was made to give a grayscale file large enough for a 20" x 30" image on A0 watercolor paper.

To allow for cropping, an 80 Mb file would be required. In RGB mode this would be a massive 240 Mb file. As the Iris RIP can interpolate up by 200% without appreciable loss, a grayscale file of 21 Mb was sufficient.

The Layers pallet is one of the most powerful tools in Photoshop.

To make new layers: Layer > New or Adjustment.

Duplicate a layer with: Layer > Duplicate Layer.

The menu bar is at the top of the screen or flyaway menu – click the arrow to the right of the menu pallet to access these commands.

The active layer is highlighted with a small brush displayed to the left of the image icon. Layers are toggled on/off by clicking on the eye.

To increase the exposure of the image duplicate layer: Layer > Duplicate Layer. Another layer is placed above the Background Layer. Select Multiply in the Layers pallet drop-down menu. The Background copy is now multiplied by 100%.

By sliding the opacity – top right of the pallet – Multiply is reduced to the required amount. Multiply at 100% is the equivalent of increasing exposure by one extra stop. **Note.** No pixels in the Background layer have been edited at this point.

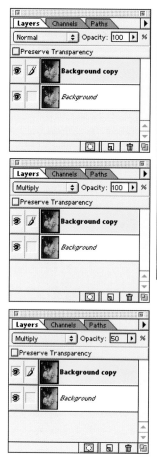

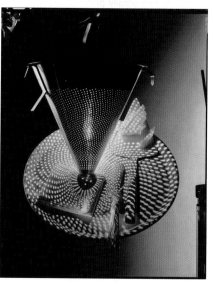

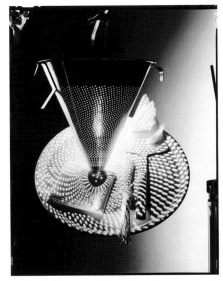

Digitally alter the grade with an Adjustment Layer: Layer > Adjustment Layer. Check Curves in Adjustment Layer dialog.

Many Photoshop users often use Levels, which works OK. I personally prefer adjustments with Curves. I believe Curves are subtler. The 'Toning with Curves' chapter illustrates this more precisely. A steeper curve, as with light sensitive emulsions, indicates an increased contrast.

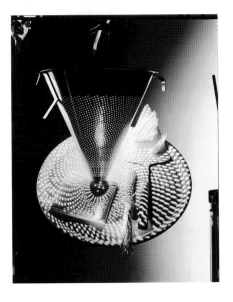

To tone the image, this time with a simple sepia similar to the darkroom image of Baker St station, make the image RGB: Image > Mode > RGB Color. This triples the file size to 63 Mb. Photoshop creates identical Red, Green and Blue channels from the original Black channel.

Double click the highlighted Adjustment Layer, notice the RGB drop-down menu. Color printers will find the RGB and CMY parallel familiar.

To sepia tone pushes the Blue curve into the Yellow. This often looks a little Green. Check the Green channel and push the curve gently into Magenta progressively removing the green cast.

Mono printers should note, Red is opposite Cyan, Green is opposite Magenta and Blue is opposite Yellow. Pushing or pulling the curves in each channel will increase/decrease Red/Cyan, Green/Magenta and Blue/Yellow. **Note.** The pixels in the Background layer still remain unedited. By building images with Layers in this way many global changes can be made without altering the original file.

At this point it is good practice to save the image as a working file.

As no pixel editing has been done this can be opened later for resizing, different color treatment, a different crop and optimized for different outputs.

Select Crop tool. Fixed target size remains unchecked. Once cropped Flatten Image: Layer > Flatten Image. Save as: File > Save As [Command/Shift/S], enter file name Final, e.g. Phil's Sieve. Final.

Photograph by Phil Jude. Originally shot on 10×8 with a wooden Deardorf camera, printed on Ilford Multigrade 4 fiber paper and toned with thiocarbimide. Now revisited in Photoshop.

Tools used
Duplicate Layer
Adjustment Layer
Mode Change > RGB
Curves
Crop tool

Burn and dodge

The Fender Stratocaster is one of my favorite icons of the twentieth century. So many fine musicians have made a great noise with this innovative instrument. I asked Phil Jude to immortalize my guitar before Rock 'n' Roll took its toll.

As in darkroom printing, where negatives are not always perfect, a scan may need some parts darkened or lightened. With a traditional print, exposure can be altered locally, by adding exposure – burning – and subtracting exposure – dodging.

This example makes use of my own choice of the three big Photoshop tools: Curves, Layers and Selections. These elements spring up in virtually every example in this book.

Curves is the digital equivalent of the characteristic curves of all silver halide materials.

Layers allow elements to be dropped in and composited with the background. Also, and very importantly, adjustment layers allow a great deal of image editing without making large alterations to the file until you are happy with the final image.

Shadows or highlights can be adjusted. Individual objects within the image can be given a different treatment to the main part of the image. Although time consuming, a well-made selection can be used to make major or subtle changes to an image.

Alas, the digital version is certainly not achieved by holding your hand or piece of card over the monitor. A similar result can be achieved by making a selection, feathering the edge of the selection and adjusting the density with Curves.

As with the previous image, all possible detail is maintained with a slightly flat scan, allowing a choice in the direction of the final image.

Increase exposure by duplicating background layer: Layer > Duplicate Layer.

Check Multiply in the drop-down menu, effectively doubling the exposure.

Create a freeform selection with the Lasso tool. I prefer to leave the feathering at 0 pixels in the Lasso Options box while selecting, then feather the complete selection.

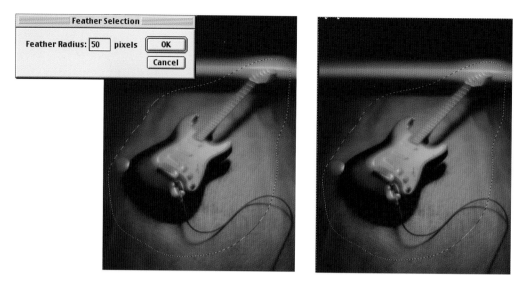

To give the soft edge that a hand or card under the lens gives in the darkroom, a large feather is applied to the selection: Select > Feather [Command/Shift/D]. The larger the number of pixels entered in the Feather dialog box, the larger the feathering or soft edge to the selection.

To allow the outside edge to be burnt in, it must be made active by inverting the feathered selection: Select > Inverse [Command/Shift/I].

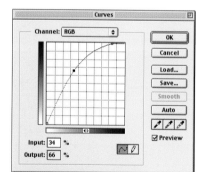

Burn in with an adjustment layer: Layer > New > Adjustment Layer. Check Curves in the drop-down menu. Pushing the curve in the mid-tones and shadow increases the exposure around the edge of the image.

Note the mask created in the Layers pallet. Using an adjustment layer allows an edit to be placed above the image. This can be altered later or even removed altogether without altering the initial scan.

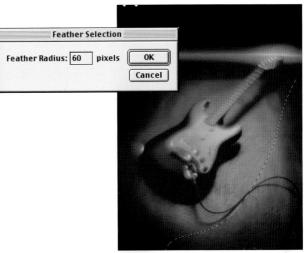

The image is still slightly unbalanced and needs further burning in, in the lower right-hand corner.

A new selection is made for the lower right-hand edge of the image and given a slightly larger feather.

A new adjustment layer is made and a repeat darkening with Curves.

Another mask for the new selection is created in the new adjustment layer.

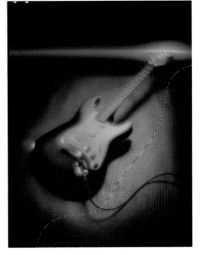

The process is repeated again for the bottom right-hand corner with a slightly larger selection and an even larger feather.

The gently feathered edge of the new selection will blend easily with the center of the image when the final curve is applied.

All these adjustment layers can be edited or adjusted by double clicking on the layer and altering the curve or sliding the opacity slider while the layer is highlighted.

Reducing the opacity will reduce the effect of the adjustment layer.

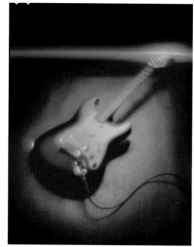

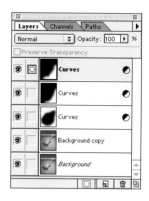

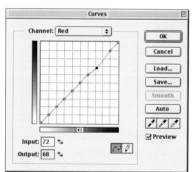

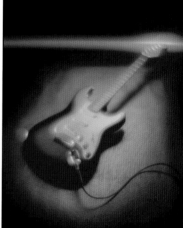

To tone the image, this time with a digital selenium color, change the mode of the image: Image > Mode > RGB. A new adjustment layer with an RGB drop-down menu allows the color to be altered in each channel. Pegging the Red curve and pulling the lower mid-tones into red introduces a selenium red.

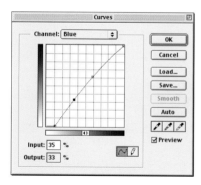

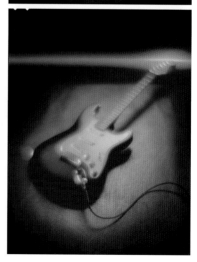

The Blue curve has the highlights pulled into the blue side of the curve, introducing the cool, neutral/red split typical of selenium.

The chapter 'Toning with Curves' gives more alternatives to using Curves as a non-chemical toner.

The contrast is increased with the RGB curve. Highlights are effectively dodged by pulling the highlight end of the RGB curve.

Now we have a layer stack to which subtle adjustments can be made. I like to think of this as a mixing desk. I tend to save the file in this layered form for future editing should the client require something different.

Guitar. 1989 brown sunburst American Standard Fender Stratocaster.

Originally photographed by Phil Jude with a wooden Deardorf 10" × 8" camera with Imagon lens.

Tools used
Duplicate Layer
Lasso tool
Adjustment Layer
Mode Change > RGB
Curves
Crop tool

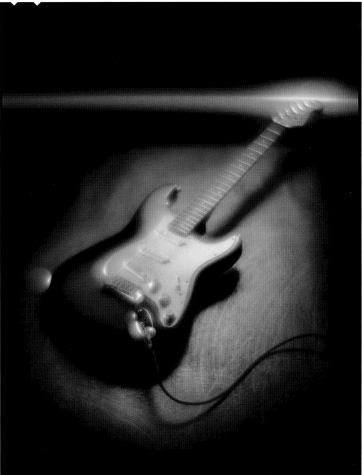

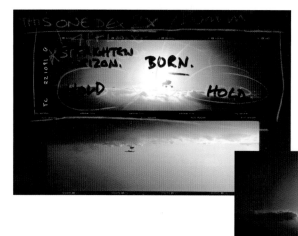

Dodge and burn

As a fan of panoramic photography I always find my delight in this format some-
what sullied whenever it is time to take the negatives into the darkroom. They
are a pain. Nobody makes suitable masks for them, except at great expense. There
always seems to be excess tape used to ensure they are held flat. I eventually made
some card masks, which could be sandwiched between glass in the enlarger. A little
bit Heath Robinson but serviceable enough. The results are often worth the effort, as
this lovely Tobi Corney picture of a microlite flying across the sun exemplifies.

Having flown many times above England's fields in Tobi's little butterfly plane, this
picture is especially significant to me. It is a difficult experience to describe. This
image, taken at 10 000 feet above Shobden airfield, shows the wonderful freedom
of being airborne. The chances of getting a successful picture using an extremely
cumbersome panoramic camera, while the instructor controlled the flying from behind,
makes this shot a one-off. The youngest person in Britain to hold a license to fly
flies the plane in front. Flying while open to the elements is absolutely breathtaking.

In the darkroom I balanced the picture as instructed on the contact sheet. On
the computer I took the toning procedure a little further by giving the image a 'split
tone' appearance, and a more three-dimensional quality by darkening the edges with
a different color, highlighting the plane in front of the sun.

Instead of merely emulating the darkroom technique of 'burning in' with my hands,
I have made a subtle selection to darken. I think a good print should feel as if nothing
particularly clever has been done to it. Although the toning with curves is apparent
I think the image appears balanced and 'natural'.

These early chapters are intended to give an overview of techniques used for
editing images. The tools in this sequence are explored in more depth in future
chapters.

When scanning monochrome images I found that scanning in RGB gave me a deeper scan. Most manufacturers will debate that this is so, and I don't wish to argue. However, I suspect that cheaper flatbed scanners don't see as well in Grayscale as they do in RGB. When I started using an extremely expensive drum scanner I was able to achieve scans with a full tonal range in Grayscale.

If you are scanning at home, I suggest that you scan in RGB and use the Channel Mixer checked to Monochrome to ensure that you have a full RGB scan with no color casts. I have a healthy mistrust of specifications and advertising hyperbole. I trust my eyes. The more you work with photography the more you learn to see.

With earlier versions of Photoshop a grayscale file could be made into an RGB image for hand coloring or toning using Curves by changing the mode: Image > Mode > RGB. With Photoshop 5.0 came the useful Color Mixer: Image > Adjust > Channel Mixer. Checking Monochrome in the dialog box removes any color caste or colored artifacts that might be in an RGB scan of a monochrome image. For the initial stages of this we want the image to behave as a black and white image. Color will be introduced with Curves later.

To increase exposure make a duplicate layer: Layer > Duplicate, and check Multiply. This effectively doubles your exposure by one stop.

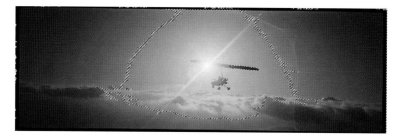

Color Range: Select > Color Range is an effective way of making a subtle selection. The feathering of the selection is adjusted with the Fuzziness controller. A smaller number is less feathering. The first time I used this tool it took quite a few attempts to get the hang of it. Now I still often make several attempts to achieve the result I want. I save the selections: Select > Save Selection and use the selection or combination of selections that work best.

Having made a selection for the highlights, it needs to be inverted to make the outside active: Select > Inverse [Command/Shift/I].

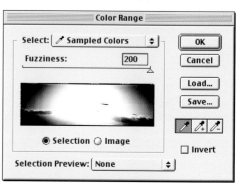

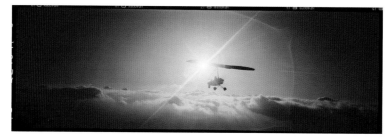

Instead of pushing the file by using the adjustment tools to push around and change the information, i.e. pixel editing, I use layer stacks. Adjustment layers using any of the adjustment tools can be stacked above the image. These don't edit the pixels till the final image layers are merged.

This is a great way of exploring any changes you might wish to make to the image without committing yourself to a final choice until you are happy with the image.

Use an adjustment layer to increase the exposure: Layer > New > Adjustment Layer.

Check Curves in the drop-down menu and push the curve to darken the print.

Highlight the Duplicate Layer and create a new adjustment layer.

Again check Curves and tone to create a sepia/blue split tone. Toning with curves will be explored much further in the next chapter.

The image is rotated slightly at the crop stage to bring the clouds and aircraft level.

Tools used
Channel Mixer
Duplicate Layer
Color Range
Adjustment Layer
Curves
Crop tool

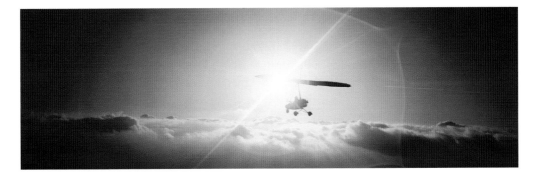

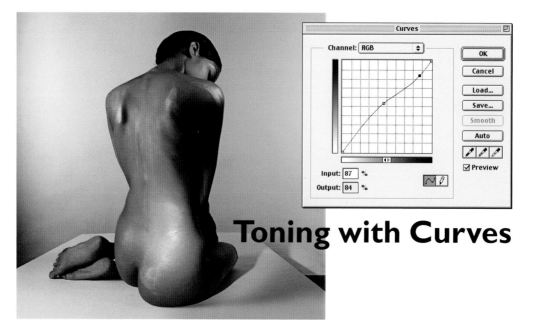

Toning with Curves

Spencer Rowell shoots exciting images, often with primitive and basic equipment using simple props. Having a strong idea of the finished image before loading his camera allows him to shoot boldly and quickly. Good knowledge of the darkroom allows Spencer to understand the final print. With this in mind he approached me to translate his mono printing ideas into Photoshop. Essentially my role is to tone the images, as I would in the darkroom.

I've witnessed many operators use Levels in preference to Curves. Levels has a great deal to do with ink levels and isn't to be ignored. Without wishing to decry this practice I personally find Curves subtler. Methods of using the Eyedropper tools, when setting White and Black points to interact with Levels settings, are shown in a later chapter. I also find Curves more predictable and controllable than Levels. Curves also bears a striking resemblance to characteristic curves of light sensitive emulsions. As I come from a darkroom background, this makes more sense to me.

Curves is a very powerful tool. Used boldly, it creates large global changes to an image. Used gently, subtle color and contrast corrections can be made.

This chapter illustrates how to avoid baths of smelly chemical toners. Using the Curves box, traditional sepia, selenium and blue tones can be emulated. Using it in conjunction with the Layers and Selections facility, split tones and colors not available through any chemical process can be made available. The image should be enhanced, not overridden by digital fairy dust. Always let taste prevail.

Opening Curves: Image > Adjust > Curves [Command/M] displays the default dialog box with large squares. Hold down the Alt/Option key while clicking in the squares gives smaller squares, enabling more control when pegging curves. Clicking in the center of the little arrows under the curves reverses the highlight/shadow. I find setting the highlight, i.e. D min (minimum density), at the bottom left with the shadows top right – D max (maximum density) – gives a 'characteristic' curve similar to the curve of monochrome paper.

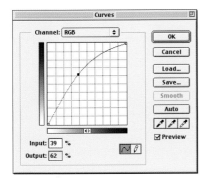

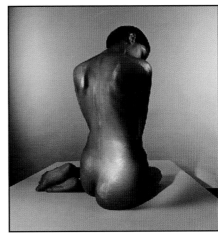

Pushing up on the curve increases density, pulling down on the curve decreases density. So visually the curve action is similar to the display shown on the monitor. More curve, more image. This suits me. This particular foible is not a must.

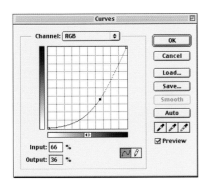

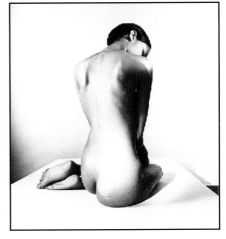

63

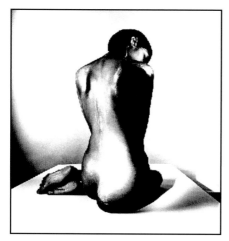

As with light sensitive emulsion a steep curve indicates high contrast, a flat curve an image with low contrast.

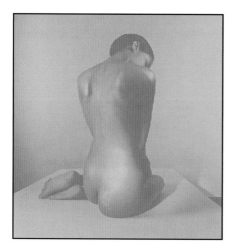

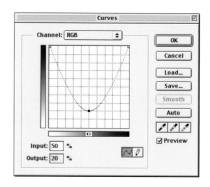

A steep curve is similar to grade 5. A flat curve is equivalent to grade 0. This is the best analogy I can find for monochrome printers.

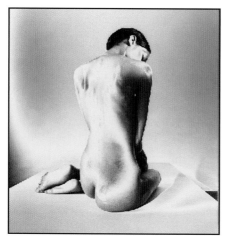

Pegging the curve by clicking a point and pushing the highlight end – D min – up into the shadow area of maximum density introduces a tone into the highlights.

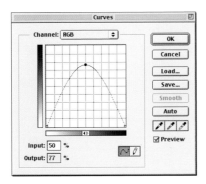

Reversing the shape has the opposite effect. Note this appears similar to the Sabattier effect, commonly, but mistakenly, called Solarization.

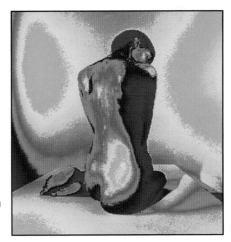

Clicking the pencil and drawing randomly over the squares in the Curves dialog box creates interesting posterizing effects.

By toggling the pencil the Smooth button previously inactive – grayed out – now becomes active. Clicking the Smooth button removes the angular bumps of the freehand curve.

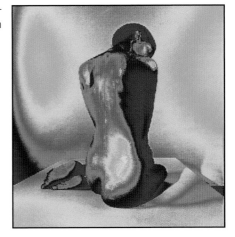

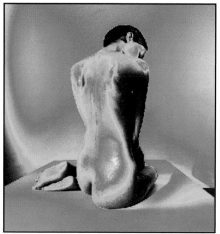

Cycling through the RGB drop-down menu and pushing the curves into unnatural shapes creates posterized effects, this time with colors. The example is probably a touch frantic. I am sure the poster and record cover designers of the late 1960s would have loved this.

Double click the highlighted Adjustment Layer, notice the RGB drop-down menu. Color printers will find the RGB and CMY parallel familiar.

Mono printers should note: Red is opposite Cyan, Green is opposite Magenta and Blue is opposite Yellow. Pushing or pulling the curves in each channel will increase or decrease Red/Cyan, Green/Magenta and Blue/Yellow.

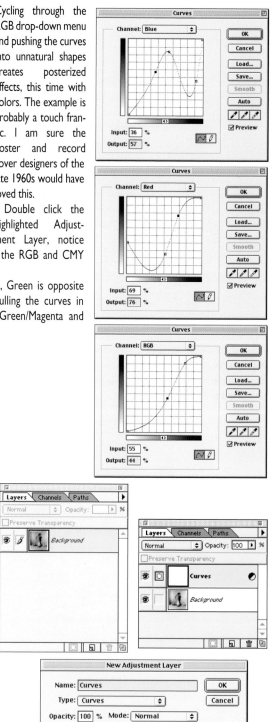

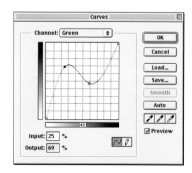

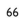

To sepia tone push up on the Blue curve into Yellow. This can often look a little green. Check the Green Channel and push the curve gently into Magenta progressively removing the green cast. With this image I pulled gently down on the curve in the Red channel. I wanted this image to have a red/brown color, less yellow than the Sieve. A final adjustment is required to put a little extra density into the shadow and brighten the highlights with the RGB channel.

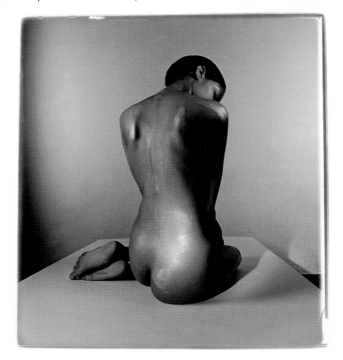

When shooting this startling image Spencer had the model dive between two sheets of polythene in a swimming pool. Risky business indeed. The original is a selenium toned lith print similar to the picture of the Fender Stratocaster guitar shot from Phil Jude.

Careful toning of lith prints with selenium often brings a red color to lower mid-tones leaving the highlights neutral with a difficult to describe cool, silver look. It is best achieved by 'whipping' the print from the toning bath before the toner has affected the whole print. Lith prints have extreme contrast but a limited tonal range. Selenium increases local contrast and creates more separation in the compressed highlights.

With careful application of Curves the 'lith' look can be emulated extremely well; it is indistinguishable when reproduced graphically. With Photoshop the extremely long print processing times and eternal frustration that accompanies this beautiful technique can be avoided.

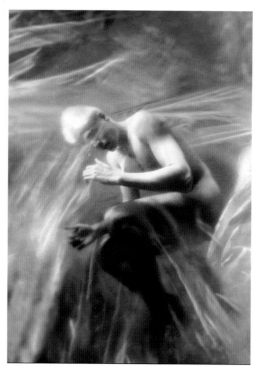

To emulate a selenium tone the red needs to be introduced to a very defined and fairly narrow part of the tonal range of the image, i.e. the lower mid-tones.

When Curves are opened: Image > Adjust > Curves [Command/M] or used in adjustment layers, the Eyedropper tool becomes the default tool in the toolbox. Clicking the Eyedropper tool on the desired area for toning with the Red curve shows a small circle in the Curves dialog box. This can be pulled to introduce the required color. Eyedropper tool feedback becomes important when color correcting.

Pegging the black just below the D max point stops the very densest blacks being affected by the curve adjustment. Pegging the highlights and higher mid-tones stops this area from being affected as well. To peg any point, click the mouse at the required point to fix the curve.

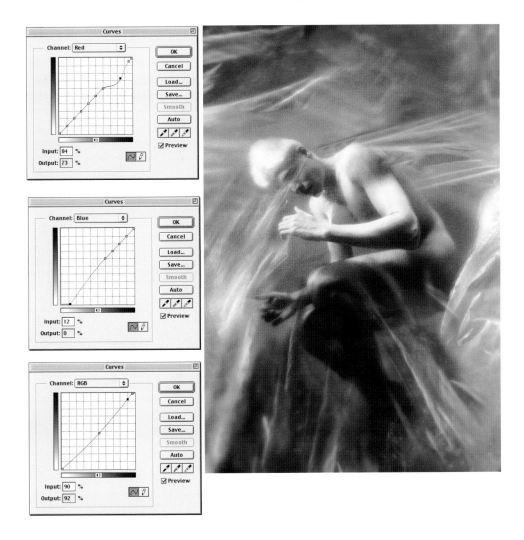

Pegging a single point and pulling one end of the curve creates a responsive swing in the opposite direction to the other side of the fixed point. To halt this, fix multiple points.

To remove any fixed point, simply grab it by clicking the mouse and pulling it off the box.

To emulate the cooler silver look of a lith print, a hint of blue was introduced with the Blue curve. Peg the darker end of the curve to allow highlights only to be adjusted.

The RGB curve is pegged at the D max end to retain all the strong blacks, while the mid-tones are minimally lightened.

Now we have a digital version of selenium toner, both controllable and non-toxic.

This rather unsettling image has always been saved to disk as Fish Ed. A rather gentle play on words. I've decided that this chap has a real mullet haircut as well.

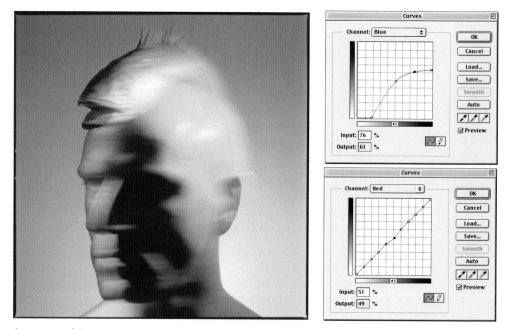

A variation of the previous tone, coupled with a blue tone, has been used. This time the blue curve is pegged in the middle with the D max, pulled over to blue in the shadows. The highlight end is pulled to give a hint of blue highlights. Pegging the curve in the center keeps the mid-tones neutral.

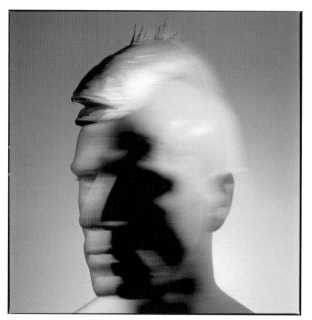

Sampling with the Eyedropper tool indicates that the central, neutral part of the curve is where the Red curve should be pulled to emulate selenium toner.

The Red curve is pegged over its entire length and pulled enough to warm the neutral tones only.

During the 1980s black and white printing enjoyed a renaissance. Many of London's top printers explored the possibilities of what various emulsion, developer and toning combinations could bring to the finished print.

One of the most extreme examples I saw was rubbed with sandpaper and had shoe polish scrubbed into the abraded surface. It looked great.

With this image Spencer asked me to give a hint of the 'abused' emulsion look to the print.

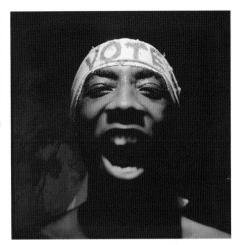

The image is first given a sepia–blue tone with an adjustment layer: Layer > New > Adjustment Layer. The Blue curve is pulled into Yellow. The highlights are held by pegging the mid-tone with the D max end of the curve being pulled into Blue. The green cast is again removed

with a small amount of magenta applied in the Green curve. The image is given a faded look by pulling the curve down in RGB.

To make the edges appear as if they have faded further, a freehand edge was made with the Lasso tool feathered:

Select > Feather [Command/Option-Alt/D]. **Tip.** Check on the desired amount of feather by applying a curve, then cancelling instead of clicking on the OK button.

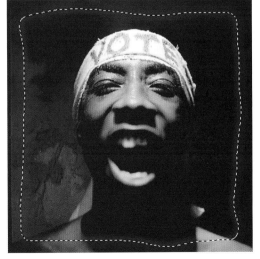

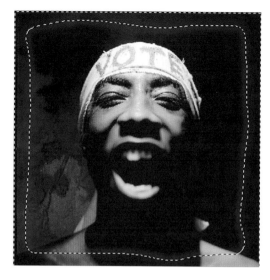

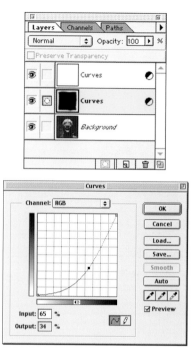

Invert selection: Select > Inverse [Shift/Command/I]. Save selection: Select > Save Selection, for later use with the image that accompanies this. While the Selection is active another adjustment layer is made.

This layer is between the Curves Layer and Background Layer. The selection has become a Layer Mask. An extreme pull on the RGB curve flattens the edges. Save the file in its layered form for future adjustment if required. Leave the image open on the desktop for editing the next image. **Tip.** Think ahead.

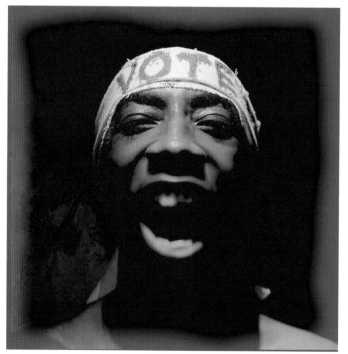

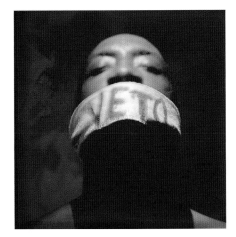 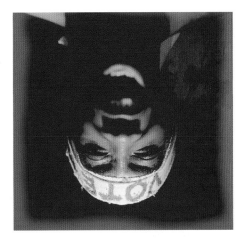

To create a matching print of the VETO picture is a simple matter of dragging the adjustment layers from VOTE into VETO. To create a similar but not exactly the same image as the VOTE rotate the image: Image > Rotate Canvas > 180˚.

Drag the Curves Layer with mask from VOTE to VETO. Holding the Shift key while dragging centers the layer in its new location.

Drag the adjustment layer to the second image. The Alpha channel selection is dragged across as well so that the selection is available for future editing.

To enable the same image adjustments to be used on both images, both negatives were scanned at the same time with the same settings.

With this pair of cats, Spencer's own (no animals were harmed in the making of this program), we decided to highlight them, with a separate tone from the background.

With traditional methods, the background would be painted out with a liquid resist. These come as rubber solutions, or strong solvent solutions, usually a red color, and have to be used in rooms with good ventilation. The mask is applied to a print that has been thoroughly washed and dried. When the solvent mask has dried the print can be toned in the normal way. While the print is washing the resist usually starts to separate from the print. Gentle rubbing with fingers removes the rest. The print is washed, dried with the whole procedure repeated for the background should a separate tone be required. Small areas where the masks haven't quite matched would then require retouching with a brush, often by a professional retoucher. If the mask doesn't quite stay stuck to the print in the toning bath, this painstaking process neads to be started from scratch.

An example, printed by me, can be seen in the late Jack Coote's *Ilford Monochrome Handbook*. A well-known London photo laboratory used this Iain McKell photograph of a tiger as an advertisement for their color department. Several versions went into the dustbin while doing this.

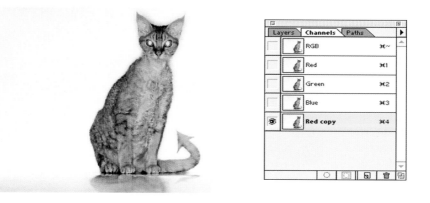

As this file started life as a grayscale, all channels remain the same when converted to RGB: Image > Mode > RGB. Any channel can be highlighted and copied: Duplicate > Channel in the flyaway menu.

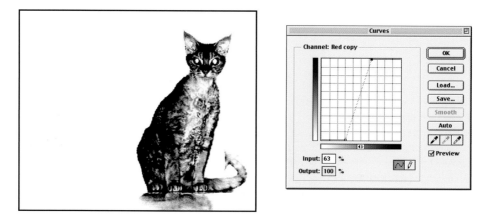

Increasing the contrast with Curves or Levels removes most of the background. A mask made with an Alpha channel retains all the fine edges of the cat's fur.

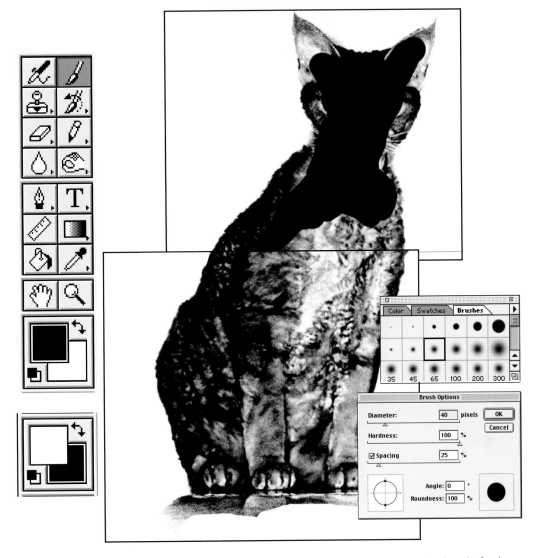

Use the Brush tool to edit the Alpha channel selection. Brushes are edited by double clicking a brush in the Brushes pallet. Moving the sliders varies the size and the hardness of the edge of the brush. Shape is altered with Angle and Roundness at the bottom of the dialog box. A new brush can be built by clicking an empty space and editing. I tend to leave brushes at the default settings and construct purpose-specific brushes when required.

Keystroke D gives a black foreground and white background.

While the single Alpha channel is displayed, the areas needing filling are painted with a black foreground. Erasing is done with the same brush tool painting with a white foreground. Toggle between black and white foreground with the X keystroke or by clicking the little arrow displayed in the toolbox.

To check the selection against another channel, click the eye icon at the left of the Channels pallet. The channel displays as a gray image, the Alpha channel being edited now displays in red. Similar to liquid mask on a bromide print.

When channel editing is complete, click on the RGB channel – all channels are now active – and then select Layers dialog: Window > Show Layers, or next to Channels in the Default pallet display.

The new Alpha channel can now be loaded as a selection: Selection > Load Selection, checking Invert in Selection dialog box.

As with the VOTE image, this can be turned into an adjustment layer: Layer > New > Adjustment Layer and toned with Curves.

To tone the background repeat the load selection sequence, uncheck Invert, repeat adjustment layer and apply the curves sequence to obtain the desired tone. **Note.** Both selections are made from a single mask, and therefore fit together precisely.

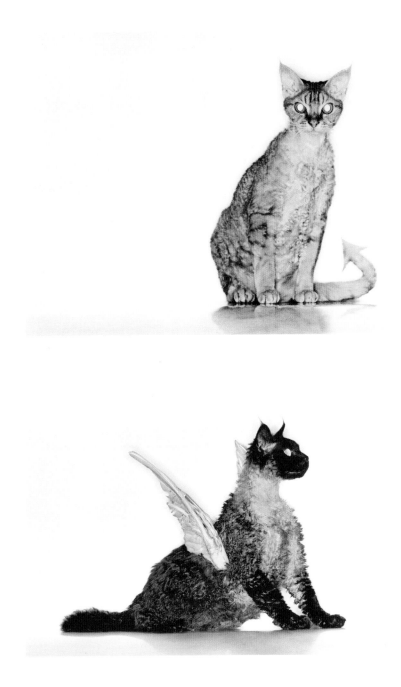

Some years ago I tried to tone with a system called Colorvir without a great deal of success. It required a pipette with two drops of solution A, plus three drops of solution B. This is extremely fiddly when the phone constantly rings. I was so busy working I didn't have the chance to take time out to get it right. Also it seemed to wash out of bromide papers.

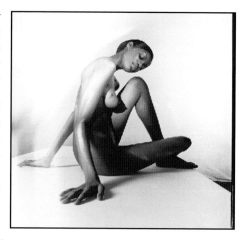

Some time later I saw a demonstration of this product and was amazed at the effects that it made possible. During this demonstration I noticed that resin coated (RC) paper was used. The purist in me shuddered. Also some of the results were a little frantic, rather like the example earlier in this chapter.

For this charming nude – the same model as the sepia image – I've stepped into digital Colorvir mode, albeit with some restraint. Pushing D min (highlights) into Yellow and D max (shadows) into Blue, coupled with an overall change in RGB channel, achieves the desired color. An extremely simple treatment.

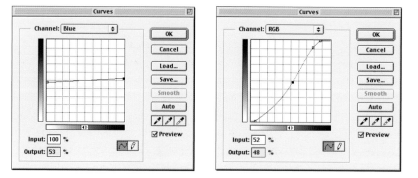

Tools used
Curves
Eyedropper tool
Lasso tool
Feather
Adjustment Layer
Layer Mask
Alpha Channel Mask
Mode Change > RGB
More Curves

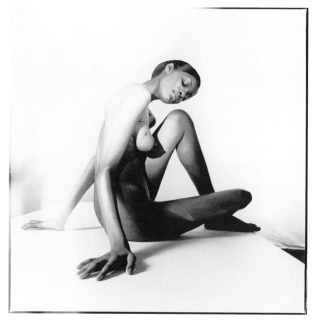

Selections

Tobi Corney asked for Kinks front man, singer/songwriter Ray Davies, to be printed with a halo, similar to Jeanloup Sief's photographs of the late 1970s, with a hint of Retro. Cutting a mask to fit the shape was difficult. Trying to achieve two matching folio prints even harder. Digital was the solution.

Creating a selection for the halo is relatively easy in Photoshop. Masks are probably the most time-consuming task in Photoshop. It is certainly worth taking time and being patient. Successful selections are not achieved with the mere click of a mouse and push of a button. Selections require the same care as painting a mask on a print. Once a good selection has been created and saved, it can be modified, the variation can be saved to another Alpha channel, and used again in any variety of ways. The selection for this image is a fairly easy technique, and doesn't need to be particularly accurate, as it is creating a soft edged halo, not a precise cutout.

Good selections need a certain amount of forethought. As with all great images planning is always a smart idea. Photoshop in my view should be used to be creative and to finish ideas, and not as a method of fixing something that is a little bit wrong.

I heard a lecture from David Bailey at the Royal Geographical Society. An admitted dyslexic his verbal articulation was not fantastic. His visual articulation still remains vibrant. There were many humorous anecdotes. My favorite is, when he asked his assistant to sweep the floor in front of the set, the response was 'It can be removed in the computer', to which Bailey said 'I am not paying £100 an hour for a computer operator to remove rubbish when I pay you £50 a week to sweep.' I feel the same about printing and Photoshop. Use it to enhance a good image and not to rescue a poor one.

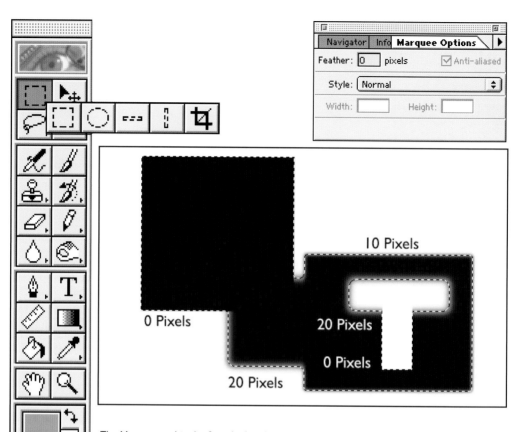

The Marquee tool is the first displayed in the toolbox. Clicking and keeping the mouse button depressed causes a drop-down menu to appear with variations of the Marquee tool. Double click for the options box. The final icon is the already visited Crop tool. The default is 0 pixel feather.

Holding the Shift key during initial selection restrains the tool to a square and a circle instead of a rectangle or ellipse. Create multiple selections by holding the Shift key while dragging the cursor over the area to be included.

Selections can be feathered in different ways by altering the feathering options before each selection. Therefore part of the selection can have a 0 pixel feather, another part can have a 10 pixel feather and another selection a 20 pixel feather. Holding the Alt/Option key allows deselection while using the Marquee tool. A completed selection can be given an overall feather with Select > Feather [Option-Alt/Command/D].

Selections are moved with the Move tool next to the Marquee tool in the toolbox. Clicking the mouse while placed within the selection, and dragging, moves the selection to a new location. The Cursor keys move the selection 1 pixel in the direction of the key. Holding the Shift key while using Cursor keys moves the selection 10 pixels.

The Lasso tools have all the same options.

Double clicking when making a selection joins the beginning of the selection with the present cursor position. An accidental third click undoes the selection. Oops.

| Navigator | Info | **Lasso Options** | ► |
Feather: 0 pixels ☑ Anti-aliased

The Polygonal Lasso allows a selection to be made with straight edges. Click with the mouse where fixed points are required.

Should a miss-click occur the delete key undoes the last fixed point.

Holding the Option/Alt key while using Poly Lasso temporarily toggles the Freehand Lasso. Releasing Option/Alt returns to the Poly Lasso. Positioning the cursor above the starting point and clicking completes the selection. With busy images sometimes the starting point is difficult to locate. Double clicking the mouse will join the starting point and the cursor.

| Naviga | **Polygonal Lasso Options** | ► |
Feather: 0 pixels ☑ Anti-aliased

Photoshop 5.0 introduced the Magnetic Lasso. The Magnetic Lasso is a major innovation making selections very quick. The Magnetic Lasso attaches itself to differences in contrast. When using a graphics tablet, increasing or decreasing the pen pressure alters settings on the fly. I've never bothered to fine-tune the Magnetic Lasso. I tend to use it for an easy selection, then fine tuning selection in Quick Mask.

| Naviga | **Magnetic Lasso Options** | ► |
Feather: 0 pixels ☑ Anti-aliased
Lasso Width: 10 pixels
Frequency: 57 Edge Contrast: 10 %
Stylus: ☑ Pressure

The final Selection tool for now is the Magic Wand. When I started with Photoshop, Magic Wand was used extensively.

| Navigate | In | **Magic Wand Options** | ► |
Tolerance: 32 ☑ Anti-aliased
☐ Use All Layers ☑ Contiguous

A better knowledge of editing selections with Alpha channels and Quick Mask almost eliminates my use of this tool except when filling areas quickly in an Alpha channel when editing selections. Unfortunately I don't find it particularly accurate.

The Color Range introduced with Tobi Corney's Microlite picture is similar to the Magic Wand and a much more subtle use of this tool.

For most monochrome images I prefer slightly flat negatives. I tend to scan with settings that will give slightly flat scans with maximum detail in shadows and highlights as well.

With Multigrade papers detail can be discarded and contrast increased. With Photoshop the same principle applies.

To allow the Magnetic Lasso tool to differentiate between the background and subject, a temporary adjustment layer is made. A steep curve is used to increase contrast.

A duplicate layer with the same increase in contrast could be used equally well. Selecting the subject with the Magnetic Lasso becomes fairly simple with the temporary high contrast layer. The temporary layer can be discarded by dragging it to the wastebasket at the bottom of the Layers pallet when it is no longer needed.

Use a graphics tablet or the mouse to follow the outline fairly closely. The Lasso jumps close to the edge between the black jacket and background. In the area near the hand and the edge of the guitar, the Magnetic Lasso will have a bit more difficulty finding the edge.

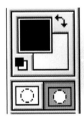

The selection is made without holding down the mouse button. The line can wander a little. Clicking the mouse key or depressing the graphics stylus fixes a point. The delete key removes the last fixed point. Repeating delete continues to remove fixed points. **Note.** Graphics tablets don't feel very organic to start with. Practice. The stylus has a feedback feature. Varying the pressure causes them to behave as a digital paintbrush or airbrush. The stylus can be programmed to behave in different ways depending on the image editing program in use. The Wacom Intuos, for example, is bundled with some useful plug-in filters.

Once the selection is made, toggle Quick Mask – located below foreground and background squares in the toolbox. **Note.** The foreground has defaulted to black with the background color defaulting to white. Quick Mask displays as 50% red. Transparent enough to see the image and obvious enough to edit. Any little glitches from the Magnetic Lasso selection can be painted in with the paintbrush with black foreground selected and erased with white foreground.

Toggle Foreground > Background by clicking the little arrow displayed or using the X keystroke.

When editing in Quick Mask is complete, toggle back into selection and save selection: Selection > Save Selection. The temporary layer – adjustment layer – can now be dragged to the wastebasket.

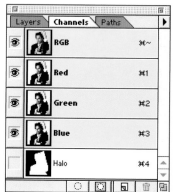

Increase exposure by duplicating the background: Layer > Duplicate Layer, and check Multiply in the drop-down menu.

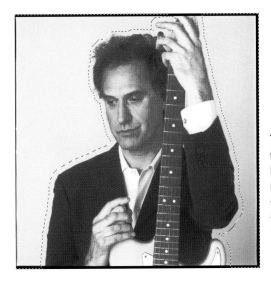

Expand Selection

Expand By: 16 pixels [OK]
[Cancel]

To create our halo load selection: Select > Load Selection. The halo needs to stand outside the central figure. Enlarge the selection: Select > Modify > Expand. The required amount of pixels can be entered in the small dialog box. Sixteen pixels is the maximum that can be entered. The enlargement process can be repeated if necessary.

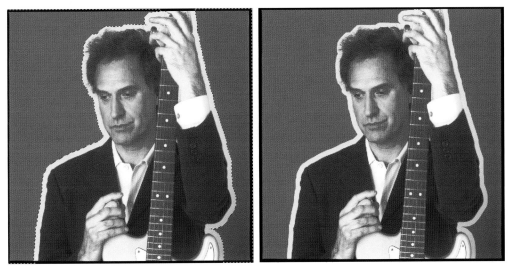

As the subject was selected and edited the background now needs to be made active. Invert the active selection: Selection > Inverse [Command/Shift/I].

Make a quick check with Curves: Image > Adjust > Curves. When you are satisfied that the selection is a sufficient distance from the main subject click cancel instead of the OK button. If the 'marching ants' are annoying, toggle them off: View > Hide Edges [Command/H]. When the selection is feathered the marching ants will reappear and need to be toggled to off again to view the full effect when the background is darkened.

Soften the edge of the halo with: Select > Feather [Command/Shift/D]. Enter feather amount in the dialog box. The bigger the number entered the bigger the feather, i.e. the softer the edge of your selection.

Hide those annoying 'marching ants' again. A quick check with Curves ensures the halo is correctly feathered – cancel again instead of OK.

Remember your selection is still active. For safety, save selection.

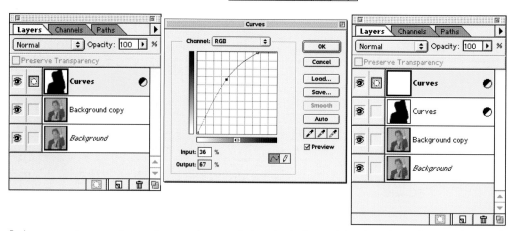

Push an excessive curve in an adjustment layer to darken the background. Load another adjustment layer with Curves to introduce a selenium tone.

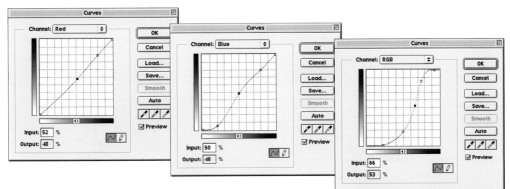

The adjustment layer curves are a variation on the curves used to tone the guitar in the earlier 'Burn and dodge' chapter.

Fine tune the background and tone with the opacity sliders of the adjustment layers. Then save as a Photoshop file in its layered form for future editing.

Tools used

Magnetic Lasso tool
Quick Mask
Paintbrush
Layers
Feather
Adjustment Layer
Alpha Channel Mask
Layer Mask
Curves

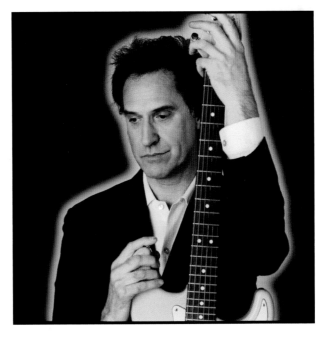

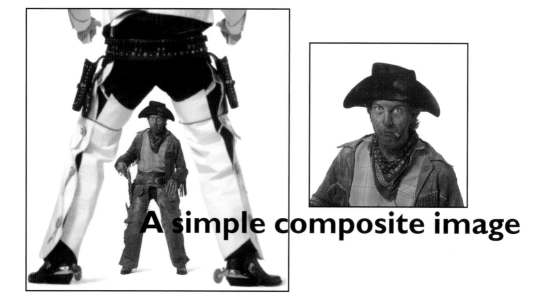

A simple composite image

This simple library image is comped together from two shots. The good guy getting the drop on the bad guy with the black hat. Instead of using a larger studio to get the perspective right, and two models, Tobi decided to use an amateur model, a builder friend whose face could be made to look grizzled enough to be the bad guy, shoot each element separately and piece them together in Photoshop. Obviously, each element could be lit separately with a much smaller lighting rig. One model could be used as well as a smaller studio. The added expense of an extra scan and an hour's Photoshop operator's fee is still cheaper than the added expense of another model, more lighting and a larger studio.

This method of working small and completing the shot in system has a logistical as well as a financial benefit. Cheaper up-front costs allow for more ideas to be tried, more shots to be done. These are very important factors when shooting on spec for stock libraries.

Comping in Photoshop allows for some of those great sunsets and wonderful skies to be dropped into other pictures without cumbersome front projection. Photoshop also allows many images to be stripped together instead of using complex sets and multiple exposures required for in-camera effects.

Thorough planning is required for composite images. Although sometimes not obvious at first glance the wrong lighting or an element not to scale often leaves the image not feeling 'quite right'. There is only one small feature of this picture which wasn't quite right but it was corrected and made believable in system. The small error is certainly noted for the next time that a similar treatment is required.

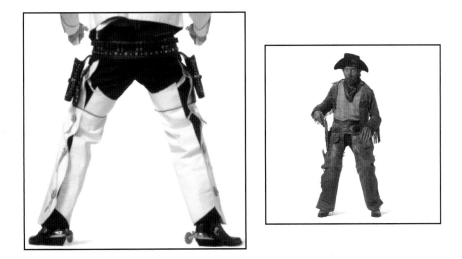

The good guy scan was made to give a sufficient file size for an A3 output at 300 dpi. The bad guy scan was made slightly larger than required. Downsizing this element to fit the gap between the white leather chaps is preferable to enlarging.

Photoshop uses pixel-based editing. Enlarging the size of a layer or selection with: Edit > Transform stretches pixels, which degrades the image. Enlarging a file with Image Size adds information by Interpolation. Interpolating up will add pixels invented by the software. Small increases in size can be got away with, but large increases are certainly not advised.

No matter how sophisticated the software is, interpolating up has extra pixels being created in software and not information from the original image.

I personally prefer working with larger files than necessary. Downsizing an image by throwing away unwanted pixels retains all the required information.

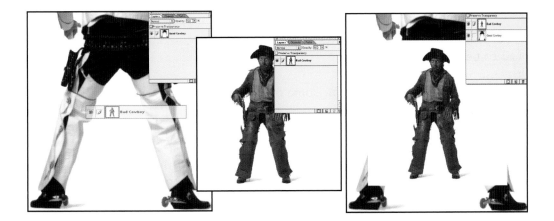

With both layers open the bad guy is dragged onto the good guy layer. Drag the layer by clicking on it and dragging to the new position. Holding down the Shift key while dragging centers the top layer.

Temporarily reducing the opacity of the top layer allows it to be lined up in the correct place with the Move tool.

Resize the bad guy layer with: Edit > Transform > Scale. Drag the corner of the selection. Move till the size and location are correct. Clicking the OK button or the return key completes the transform.

The Transform tool is worth exploring. Matching the scale of backgrounds when dropping images into them is relatively easy. Converging uprights can be made parallel, thereby reducing the need to have extreme movements in large format cameras.

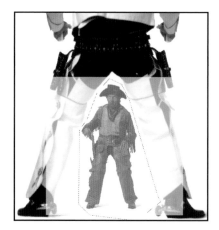

Before sliding opacity to maximum, a selection of the smaller image is made with the Freehand Lasso tool.

Invert selection: Select > Inverse [Command/Shift/I] and delete: Edit > Clear [Delete].

This is an extremely simple composite. Fortunately the shots were all from the same shoot and the same film stock. I didn't have to get into color matching files from different sources.

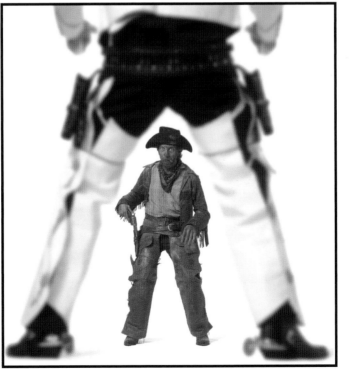

When the image is returned to full opacity the foreground is far too 'in focus' and looks a little mechanical.

While the file is still in layered form, a small amount of Gaussian Blur throws the foreground out of focus.

Tools used
Drag Layer
Move tool
Layer Transform
Lasso
Gaussian Blur

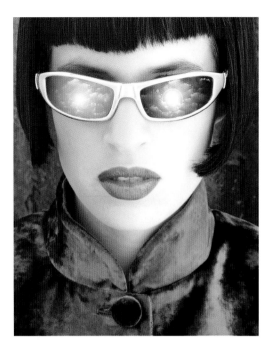

More selections

This section features more tools than the heading would suggest.
Here we are going to enhance a picture of Jade Jagger, daughter of Rolling Stones singer Mick Jagger, taken by Bob Carlos Clarke, and then take it one step further with a monochrome split tone.

A good professional retoucher could possibly do the color treatment by hand. I doubt that I could achieve the same split tone in the darkroom, but I think the result looks like a darkroom print. The truly wonderful thing about Photoshop is the ability to achieve a believable result that isn't possible conventionally.

The main problem with the picture is the studio reflected in the sunglasses. Discussing this with Bob, I suggested that a landscape could be dropped in and blended with the lenses to look like a reflection, thereby suggesting a location instead of a studio shot. After some rummaging around amongst some out-takes, Bob produced a couple of transparencies of clouds in a blue sky for the blue lenses and a London skyline at sunset for the shot with the brown glasses. Ideal for what we had in mind.

Because Jade has great skin not much retouching was needed to keep her face clean. A great complexion makes my life easier.

The studio reflections were easily removed with the Clone tool. The real trick was to blend the scan of the skyscape and the lens, and make it appear believable.

The initial scan shows the flats reflected in the lens. These are removed with the Clone tool and Paintbrush, as shown in the removal of the leaf in the chapter 'My first image'.

Normally I don't use the Magic Wand. As the lenses here are generally shades of blue surrounded with a silver frame, the Magic Wand tool at its default setting of 32 pixels is ideal for this selection.

The selection is added to by repeat clicking with the Magic Wand while holding down the Shift key.

As with the image of Ray Davies, clean up any minor selection glitches in Quick Mask.

To avoid the work in the lenses appearing cut out, a very gentle feather of 0.5 of a pixel is used. It is possible to feather as finely as 0.2 of a pixel. Save selection.

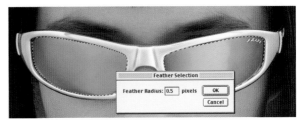

93

While Selection is still active, duplicate the background layer: Layer > Duplicate. Invert selection: Select > Inverse [Command/Shift/I].

To leave just the lenses to edit delete the rest of the image in duplicate layer. Edit > Clear [Delete].Toggling the background layer shows the layer with the lenses.

Select the right-hand lens with the Marquee tool.

Relight the lens with the lighting effects filter: Filter > Render > Lighting Effects. Choose the spotlight option. Emulate light shining on glass with the sliding controls in Properties Adjust to put a strong highlight in the middle of the lens by pushing to give nearly maximum shine, and enhancing the reflective metallic lenses by setting Metallic to 100% with the material slider.

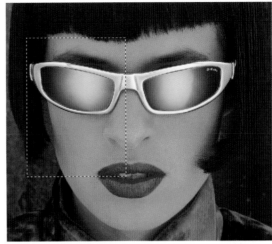

The left-hand lens is selected, again using the Marquee tool, and the filter is applied to the lens at exactly the same settings. Center the spotlight in a similar position on the second lens. Now we have two spot lit lenses.

The clouds scan is dragged over the right lens creating another layer. Resize to cover the lens: Edit > Transform > Scale, the same process as resizing the cowboy in the previous chapter. Duplicate clouds layer: Layer > Duplicate Layer. Position the clouds over left lens with the Move tool.

 Clicking the eye icon to the left of the pallet turns off all the other layers. Select either cloud layer and merge: Layer > Merge Visible puts separate cloud layers into a single layer. Load previously made lens selection: Selection > Load Selection and repeat the deletion sequence to remove the clouds outside the lens area.

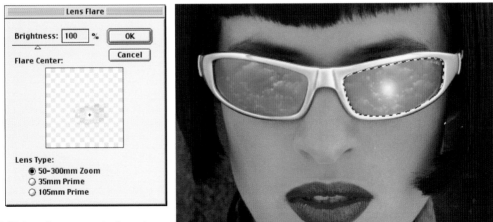

Add lens flare on a duplicate layer:
Layer > Duplicate. Select the right lens with the Marquee tool and select Lens Flare filtration: Filter > Render > Lens Flare. Adjust brightness with the slider control. A choice of prime and zoom lenses is available in the dialog box. Select the left lens and repeat the procedure. Each lens is treated separately to avoid spill from each filtration onto the other lens.

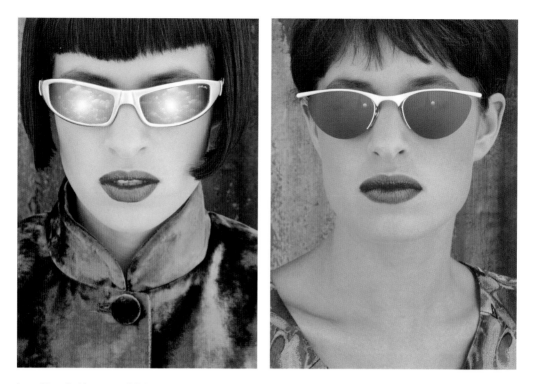

I would really like to see Adobe develop the lighting effects filter into a virtual studio. Images rendered in 3D packages could be edited, relit to have the lighting match backgrounds and dropped into stock backgrounds with the familiar Photoshop interface.

The possibilities are endless. With careful use of selections and layers it is already a powerful filter. Unfortunately the filter dialog is not comprehensive enough and the preview is too small. One day.

Version 2 of this image is a toned monochrome image. With previous versions of Photoshop this would have required making a grayscale file and then taking it back into RGB. Checking monochrome in the Channel Mixer

dialog box: Image > Adjust > Channel Mixer leaves the file as RGB with grayscale appearance. I must confess ignorance of some of the possibilities available with Channel Mixer. Channels can be adjusted with this dialog. I still come back to Curves. I find the Curves process much more predictable. I can sample then bend tones subtly.

Levels can be used to brighten the image. Pulling the right-hand slider towards the left the face can be brightened, or a white point can be selected using the Eyedropper white point selector in Curves.

Toggling the right-hand Eyedropper in Curves and clicking on a point chosen as a white point brightens the image.

The minimum ink output, i.e. no ink, often leaves the image appearing with highlights bleached out. If the file were to go to reproduction there would be no dots on the plate to leave ink on the paper.

To allow information in the highlights to remain, bring up the Color Picker dialog box by double clicking the Eyedropper button in Curves.

Typing in a value less than 255 D min, e.g. 245 in RGB channels, the white point is clipped leaving a hint of tone.

The black point Eyedropper can be changed in a similar way so that shadow detail retains tone. Instead of 0–D max, it can be raised to a higher level by entering a higher value in the RGB channels in the picker dialogue box, i.e. 10 or even 20 could be entered. This is the same as clipping the maximum output (maximum amount of ink applied) in Levels. For want of a better technical description this keeps tone in highlight and stops the shadows blocking up.

Duplicate background layer: Layer > Duplicate. For layer navigation I've renamed the layer Blue.

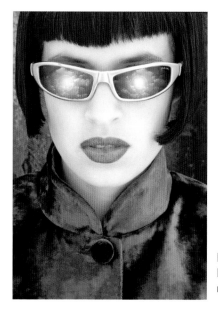

Highlighting the background layer, then create an adjustment layer: Layer > New > Adjustment Layer, check curves in the drop-down menu and sepia tone with Curves.

Make an over-the-top sepia. This can be fine tuned with the opacity slider when the top layer has been toned.

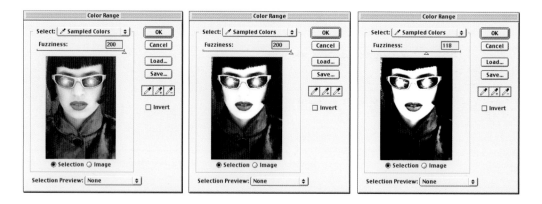

To create a layer mask in the background copy, i.e. Blue layer, make a selection with Color Range: Select > Color Range. Color Range is a sophisticated Magic Wand with a great deal more control. Toggle Fuzziness to a maximum of 200. With the left-hand Eyedropper click on the highlight.

Highlight can be selected in the Color Range dialog or on the image itself. Add to selection by holding the Shift key and clicking in the areas you that wish to add. Sliding the fuzziness controller curtails the feathering of the selection. I have found that several attempts are sometimes required to achieve a satisfactory selection.

The Color Range selection at present would allow sepia highlights to come through in the lens flare area of the image. Keep the lenses blue by cleaning up in Quick Mask. Save selection: Select > Save Selection.

I have a very belt and braces attitude to saving selections. If they have taken time to make I don't want to lose them by an accidental click or two. A habit left over from painting masks on prints and one level of undo in Photoshop 3.0 and 4.0.

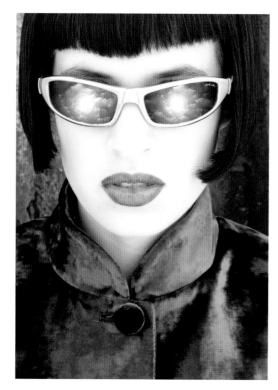

Create a layer mask, first by highlighting background copy, then while the selection is active: Layer > Add Layer Mask > Hide Selection.

The blue split tone in the shadows is made in an adjustment layer with the Blue channel in Curves.

By default the adjustment layer would tone the whole image. Group the background copy with the blue adjustment layer by holding down the Alt/Option key while clicking the line between the layers in the Layers pallet. Now the adjustment layer will tone only the masked layer.

A sepia adjustment layer can be grouped with the background copy to give a sepia with a neutral background. Use the layer stack as a mixing desk to toggle off layers and vary the sepia, blue and neutral layers. Achieve gentler tones with the opacity sliders.

Tools used

Magic Wand
Quick Mask
Lighting Effects
Lens Flare
Channel Mixer
Color Range
Duplicate Layer
Adjustment Layers
Group Layers

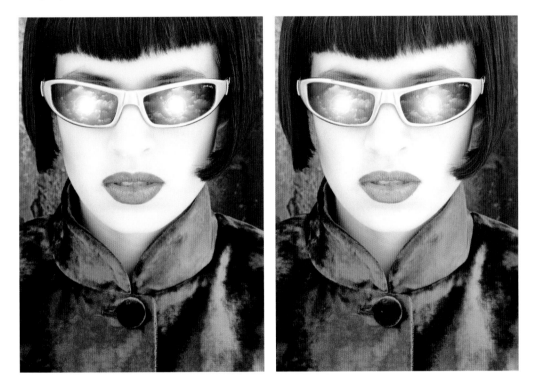

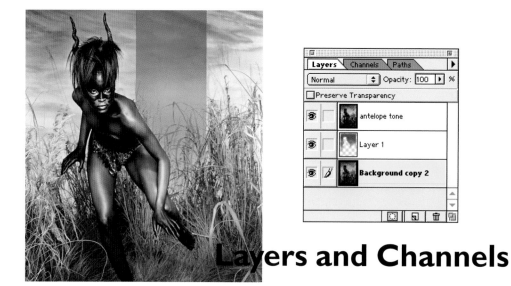

Layers and Channels

Bob Carlos Clarke presented me with a challenge. To fulfil a specific brief, I had to emulate Bob's distinctive printing style for his first Powergen personality calendar.

I would be used to doing this in the darkroom. This was early days for using Photoshop. In fact it was Photoshop 3.0. I hadn't really come to grips with selections or Alpha channels at all.

BOB CARLOS CLARKE

Dear Max

I enclose neg and rough print of "Antelope".

I think it need more punch/contrast.

Sky could be richer at the top. Right leg could go darker and bottom of grass.

Split-tone or similar might help, but no unsubtle shades please. Maybe a pinky-purple sunset tint in part of lower sky - but very gentle.

What do you think?

Work your magic, Maestro!

PS Please guard neg with your life and keep print safe too. Thanks.

Very rarely do I meet photographers who are as equally adept in the darkroom as they are with a camera. Many of Bob's early multiple exposure prints were made by hand in a darkroom without running water. So here was a client who really knew his darkroom. I couldn't bluff my way through this.

This was done in Photoshop 3.0 and my knowledge of the program was considerably more limited than it is today. There were also fewer good manuals with tips to steal. It took a few false starts. I learned as I went along with this image.

As a result I learned a great deal about making the various facets of Photoshop work laterally instead of in a linear way.

When there are a lot of similar images, and a single specific use for the images and time is at a premium, I would optimize images as much as possible at the scanning stage, thereby bypassing a few of the steps I might make at the manipulation stage.

When quality is of the essence and the luxury of experimenting is possible, I scan at settings that allow as much latitude as possible. The original scan is usually a little flat, so that shadow and highlight detail is retained.

A few small blemishes, wandering blades of grass and the border are cleaned up at this stage, as I want to retouch one layer not several. The point at which retouching is done is not fixed. If treatments don't require a great deal of retouching I often leave it till just before the image is sent for output. Rather like spotting a print.

Select channels: Widows > Show Channels, or next to the default layers panel. The Channels pallet can be dragged out of this box and stand alone so that both Layers and Channels pallets can be displayed simultaneously. With two monitors all your pallets can be displayed and left open instead of opening and closing with the constant: Window > Show Layers.

Duplicate channel to create a selection similar to the cat in the 'Toning with Curves' chapter.

Once the model Hermione is painted in, a quick tweak with Curves to clean the background is useful.

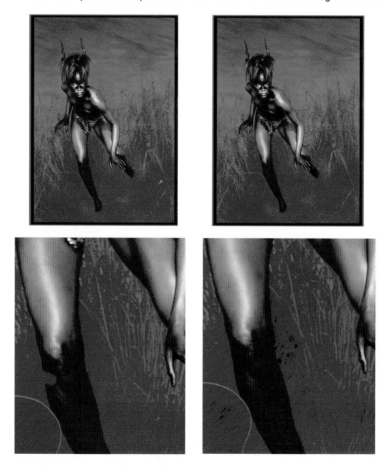

Fine tune the selection by turning the Black channel on for reference. The Duplicate channel is displayed as 50% red, similar to Quick Mask.

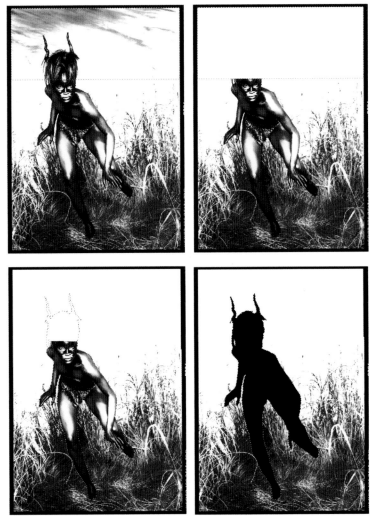

For this image I loaded the new Alpha channel selection: Select > Load Selection, and then inverted the selection: Select > Inverse [Command/Shift/I] and saved: Select > Save Selection, for editing the girl later in the treatment. Make another Duplicate Black channel. Increase contrast with Curves or Levels.

Check that the white background is selected in toolbox foreground/background colors.

Toggle with the X key if necessary. Select an unwanted section of sky with the Marquee tool and delete.

Load the girl selection: Select > Load Selection.

Fill the selection with black: Edit > Fill Selection. Select > Deselect [Command/D] deselects the loaded selection.

The grass in the foreground is painted in and then checked by making the Black channel visible. Clicking the the eye icon makes channels visible.

Clicking on the channel makes it active.

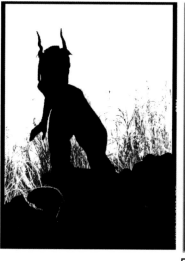

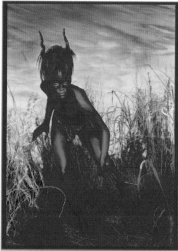

This selection will be used to paint the sky. Load this channel as the selection: Select > Load Selection. Now invert: Select > Inverse [Command/Shift/D] and save as Sky Channel.

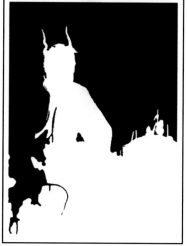

Make the grayscale file into RGB: Image > Mode > RGB. Toggle back to Layers. Highlight the background layer. Create a new layer in the middle of the layer stack: Layer > New > Layer [Command/Shift/N].

With the empty new layer highlighted, load the Sky Channel selection. To keep the edges from looking too cut out, apply a half pixel feather: Select > Feather [Command/Shift/D].

Open the Color Picker by double clicking the foreground color in the toolbox. Choose a strong red. Paint in the sky using a large soft edged brush. Don't paint too close to the grass. Keep edges indistinct. The active selection stops Hermione from being painted over.

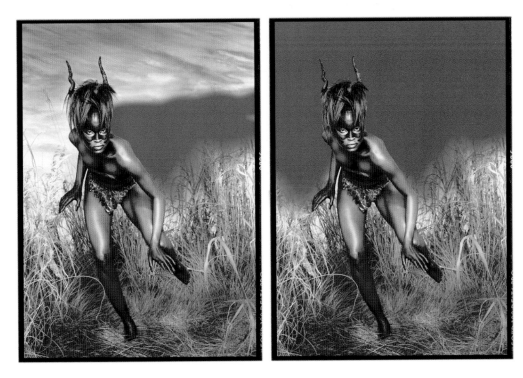

Choose a strong yellow with the Color Picker. Paint randomly over the red.

107

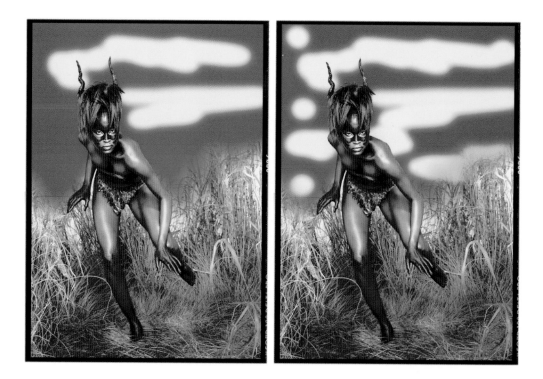

Blend the sky by applying a strong Gaussian Blur: Filter > Blur > Gaussian Blur. The Gaussian Blur only affects the color within the still active Sky selection.

Now we have the beginnings of a hand painted sunset.

Highlight the background copy – the top layer in the stack. Invert the Sky channel selection and apply strong selenium tone in Curves with an adjustment layer.

A layer mask is created from the active selection. This way only the girl and foreground are selenium toned, the sky remains neutral. A similar tone to the guitar in the 'Burn and dodge' chapter is ideal.

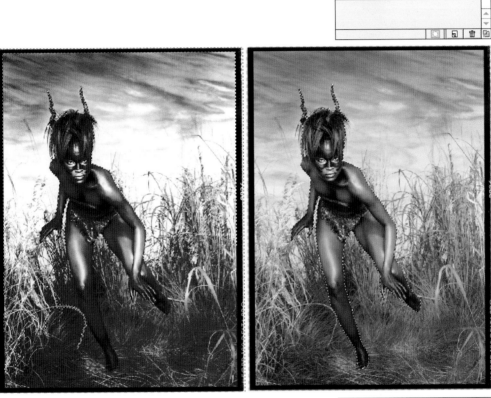

Load the selection of Hermione – the GIRL ALONE – Alpha channel. Increase the contrast and density of the girl with Curves in an adjustment layer to make her stand out from the background. Again the adjustment layer creates a layer mask from the loaded selection. Now we have a five layer stack.

Reduce the opacity of the background copy, i.e. the middle layer blends the strong selenium tone with the neutral background original. Reducing the background copy also allows the hand painted sky to filter through. Reducing the opacity of the hand painted sky layer allows the sky to blend with the neutral clouds from both the background and copy. The contrast and tone can be fine tuned with the opacity sliders.

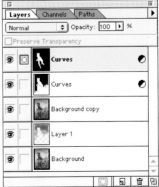

Save as layered image. The different layers are saved, as are the selections as Alpha channels. This way the image can always be reloaded and re-edited with a different sky. Different tone combinations can also be tried.

Tools used
Duplicate channel
Duplicate Layer
Paintbrush
New Layer
Color Picker
Gaussian Blur
Adjustment Layer
Curves

'tomorrows impossible paradise'

LAURA 4·6·96

A complex composite image

This composite image was a collaboration between Laura, the model, Tobi Corney, the photographer, and the computer operator, me. Laura had an idea of how she wanted to be represented. Tobi knew what he wanted the picture to look like. My job was to interpret.

I am not quite sure of the symbolism but I like the feel of the image. It was intended for the Kobal Portrait Awards. Needless to say it was a little off the wall to take a prize. I think at the time, when the Iris print was presented, the judges were a little dubious as to whether this was real photography. I am sure if it had been presented on photographic paper it would have been more acceptable.

Since then I have presented prints for folio and exhibition for many photographers on watercolor papers. In the three years since this picture was constructed water-color papers printed on high-end machines like Iris and cheaper desktop printers designed for SoHo – Small office Home office – such as the Epson range, now commonplace, are seen as the 'way to go'.

Comping the two backgrounds wasn't a particular problem and could have been easily done in the darkroom. The main concern was that the rubbish spilling from Laura's hands was great in one shot but her eyes were all screwed up. With this construction we thought putting a better head in place was acceptable. As a satirical exercise I would not have a problem creating a Spitting Image type of illustration using Photoshop.

I believe images should maintain an integrity that is geared to the image use. Fortunately I have managed to avoid working with pictures of fast food. It always appears bigger and fresher on the billboard than it does when you eat it.

This is really a case of pre-planning. The first priority is to get the background ready for the foreground, Laura, to be dropped on top. Then tighten up the composition and tone.

Open the first background shot – in this case a picture of London's busy Oxford St.

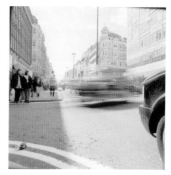

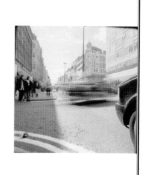

To make a big enough area for the image to be moved about, increase the canvas size: Image > Canvas Size.

Click the center box on the right-hand side; enter a measurement to increase the size of the picture. Now we have a large, blank canvas on to which we can drop any image we choose and move it till we are satisfied. The downside is this will also increase the file size quite considerably.

All that blank canvas, although currently empty, is pixels using precious RAM. With a monochrome image it is faster to work with it as a grayscale until color elements are required. Instead of editing three RGB channels, only one grayscale channel is being edited, which is far more efficient in processing time. Unless you possess a brutally fast machine with excess RAM, or the image is only small, this will save the tedium of progress bar frustration.

Open the second background image. This time an image of the Dorset coast. Drag from the Layers pallet onto the background.

Place the second image centrally on the background by holding the Shift key while dragging the layer.

Toggle the Move tool and move the Dorset image approximately to its final place.

As this comp requires quite a few layers double click the layer and rename. Save the file for safety.

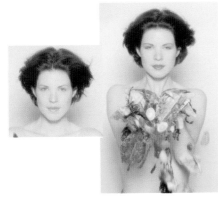

This is a mini-comp to give Laura a better disposition. Both Laura and the better Laura head were scanned at the same time with the same settings. The Laura head image was cropped at the scan stage. Other than this variation all the other scanner settings remained the same.

Both files are opened. As with background layers Laura's head is dragged onto the body.

As this scan is slightly flat a temporary adjustment curve to increase the contrast is placed on top: Layer > New > Adjustment Curve. Aligning the two layers is easier with the opacity of the top layer reduced.

The variation in the pose of the Laura headshot requires a small adjustment to the top layer for it to sit comfortably on its new shoulders. Edit > Transform > Rotate selects the top layer. Clicking on the corner and dragging clockwise/anticlockwise the top layer can be aligned. The top layer is only slightly too large. Edit > Transform > Scale reselects the top layer. Holding the Shift key while dragging the corner keeps the selection in proportion horizontally as well as vertically while rescaling. Return opacity to normal.

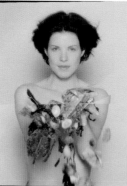

The unwanted part of the top layer can be removed with the Eraser tool. Select Paintbrush in the Eraser Options. A soft edged brush from the Brushes pallet would suit this operation.

Erase the image where it overlaps on the shoulders. The best place for the transition between the background and top layer is at the neck. Don't worry where the backgrounds overlap, this will be removed with the mask that is made in the next part of reconstructing Laura – before and after makeover. Flatten the image: Layer > Flatten Layer.

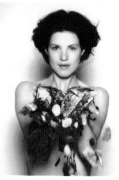

Making a selection with this image has a two part solution. The first part is to make an Alpha channel for editing by duplicating the Black channel.

Brighten with Levels. This is not image editing but selection creation; precision is not important, so slide the right-hand slider enough to lose most of the background.

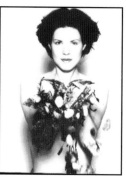

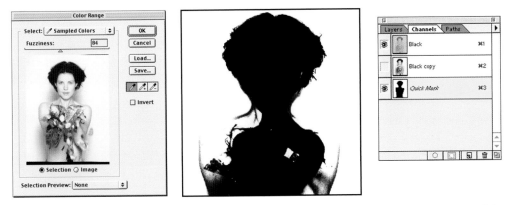

There is still a shadow behind the neck and hair that would be difficult to edit with a brush. Color Range: Select > Color Range with Fuzziness tightened up creates a better separation between the background and Laura. Editing the rest of the selection is relatively easy in Quick Mask.

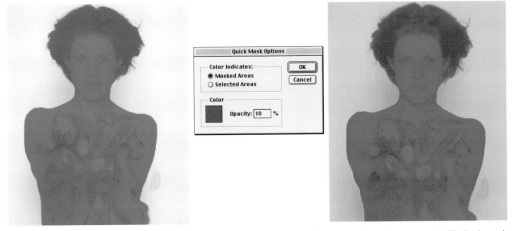

With a flat image, the Quick Mask overlay can be too dense to see the image for reference – the Black channel that is turned on. Double clicking the Quick Mask tool in the toolbox opens a Quick Mask Option box where the opacity can be altered. The red overlay color can be altered as well. Double clicking the red square opens the Color Picker where a custom color can be chosen.

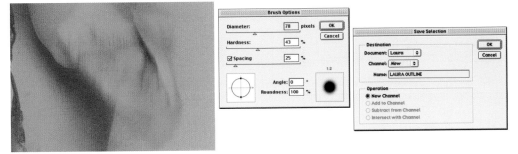

Where the rubbish is spilling from Laura's arms a soft edged brush is used to allow the movement to have a softer edge when overlaid on the background. Save the selection.

We have a two-pass solution to create an editable selection. The other option, instead of Quick Mask, is to save the Color Range selection and edit the Alpha channel directly.

Photoshop allows several ways of achieving similar objectives. This can vary from image to image. There is no singular correct solution. Be aware that different methods can be used. The real trick is to figure out which method suits the image. Often it is the cumulative effect of several.

Resize the file to fit the background. Instead of reducing the file to six inches in height in one go, reduce the file in steps of 50%.

The software throws away every second pixel vertically and every second pixel horizontally. This is easy maths for the software to deal with.

Then reduce the file to the correct size where the complex maths takes place with a small file. This way there is less distortion and loss of quality. You will notice the 'jaggies' less with a type layer if the downsizing is stepped this way.

If the file needs to be reduced to a very small size, it is sometimes better to scan it as close to the output size as possible. A massive reduction is pixel editing. Each reduction changes the relationship between the adjacent pixels, thereby progressively creating distortions.

With the reconstructed Laura and the background composite open, drag Laura onto the background, remembering to hold the Shift key to center the new layer. Keep the Laura image open for the time being.

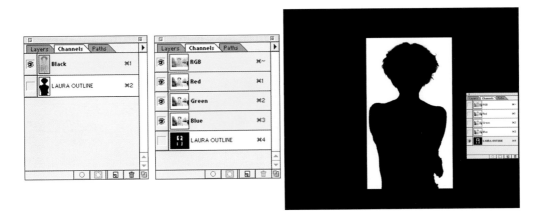

The channels in this image are complicated. To edit a selection for Laura would be at best irritating and time consuming. It is much easier to create it at the reconstructing Laura stage. Drag the Alpha channel selection across to the background from the Laura image.

Make the Laura image active. Open the Channels pallet: Window > Show Channels or next to Layers. Drag the Alpha channel the same as a layer. Hold the Shift key while dragging. The selection is now lined precisely with Laura in the comped image.

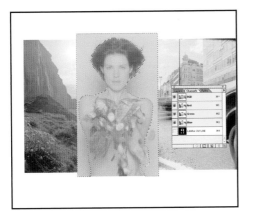

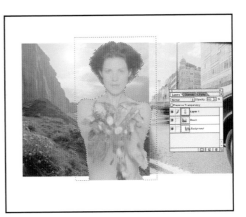

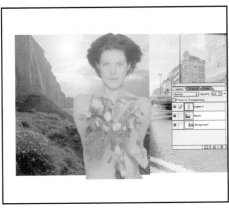

Load selection: Select > Load Selection.
Invert selection: Select > Inverse [Command/Shift/D] and delete: Edit > Clear [Delete].

Now the basic elements are assembled, the image can be fine tuned.

There are two small unavoidable faults with the image of Oxford St.

First, the car on the right is stationery and vying for attention with the main subject. The second is the signage for a well-known High St retailer which, we decided, wasn't really wanted in the image. The solution was simple. Make the car bigger and blur it.

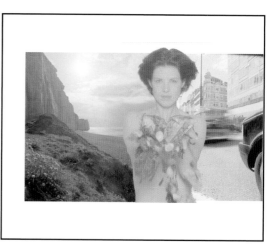

To help the Magnetic Lasso tool a temporary adjustment layer was placed above the Oxford St layer.

Curves or Levels adjusts the contrast. The car is selected with the Magnetic Lasso and the selection is tidied up in Quick Mask.

Before adjusting the car modify the adjustment layer to give Oxford St a similar tonality to the Dorset coast layer.

Adjustment layers have the added bonus of not only being able to aid in the making of a selection as we have done here, but can be readjusted in the dialog opened by double clicking on the highlighted adjustment.

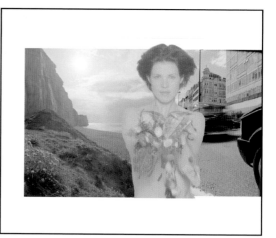

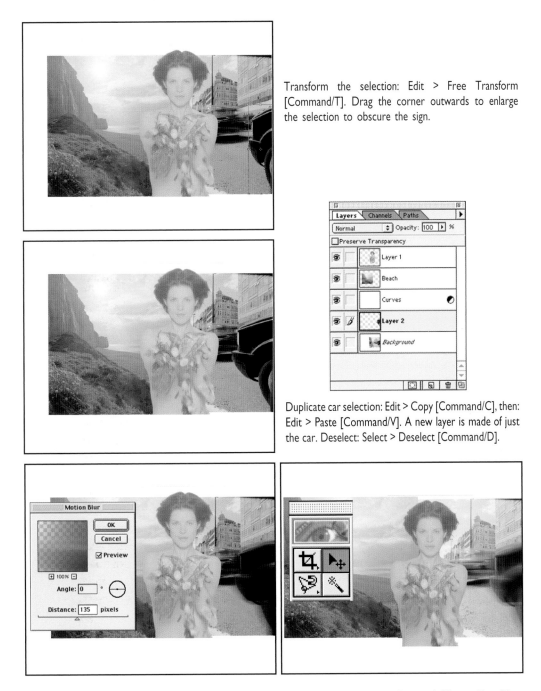

Transform the selection: Edit > Free Transform [Command/T]. Drag the corner outwards to enlarge the selection to obscure the sign.

Duplicate car selection: Edit > Copy [Command/C], then: Edit > Paste [Command/V]. A new layer is made of just the car. Deselect: Select > Deselect [Command/D].

To bring it in keeping with the other hustle and bustle in this background element, filter with Motion Blur: Filter > Blur > Motion Blur. In the filter dialog the direction of the blur can be moved through 360° and the distance of the blur can be adjusted. The Dorset coast layer can be moved to its final position by highlighting the layer and moving with the Move tool.

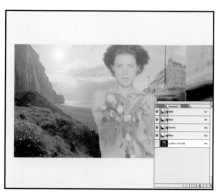

Given all the work done to this point plus my belt and braces thinking, I would save a working version of the file at this point.

Toning the background is another simple adjustment layer with a hint of blue and overall RGB adjustment.

There are three ways of toning Laura.

Simply group the adjustment layer with the Laura layer by clicking the line between the two layers while holding the Alt/Option key. Delete extraneous parts of the Alpha channel selection before loading to remove the Laura background.

After loading the selection, inverting and deleting background, a layer mask can be created.

As with the image of Jade Jagger, while the selection is still active create a layer mask: Layer > Add Layer Mask > Hide Selection, then group the adjustment layer with the Laura layer by clicking the line between the two layers while holding the Alt/Option key.

Show channels, turn the Alpha channel on, and highlight. As Laura has been moved the selection is not aligned.

With the Move tool still active, move the channel until it is nearly aligned.

Zoom the image up to give a closer view. Move the mask with the Cursor keys to align precisely. Each click moves the mask 1 pixel. Holding the Shift key moves the mask 10 pixels, in the direction of the key.

With the channel display select inside the rectangle containing Laura. Invert selection: Select > Inverse [Command/Shift/D] and delete: Edit > Clear [Delete].

Load the new Laura selection: Select > Load Selection. Introduce a tone with a new adjustment layer, creating a layer mask in the curves channel. This last method might seem long winded, but as we have spent a long time making an accurate selection while reconstructing Laura, it's worth aligning with the image should extra editing be required in the future. There is no right or wrong. The objective is achieved.

Crop to final shape. Leave enough white border for the signature.

Create a marquee selection of the bottom part of the image and delete.

Toggle through the layers and hit the delete key to remove any rubbish that hasn't been cleaned up. Now the image is left with a white base to drop the signature.

At this point it's time to reduce the file size by merging some layers.

Turn off Laura with her adjustment layer and the adjustment layer for the background.

Highlight any of the image layers, i.e. the car, Oxford St or Dorset, and merge: Layer > Merge Visible.

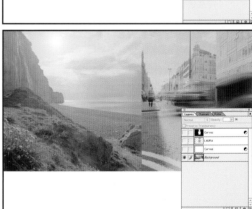

All the elements creating the background have been merged to a single layer with an overall adjustment layer plus Laura with her adjustment layer.

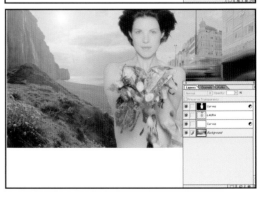

The signature is dragged from another scan to form another layer. Save as Laura Nearly.

Note. To illustrate this chapter I had to recreate the image. The alignment and tones aren't accurate, but serve the purpose of illustration. The final image wasn't quite as frantic.

Tools used
Canvas Size
Drag Layer
Adjustment Layer
Transform – Rotate
Transform – Scale
Eraser
Levels
Color Range
Paintbrush
Image Size
Transform – Free Transform

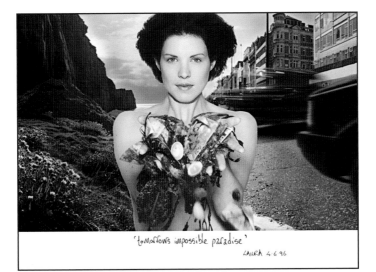

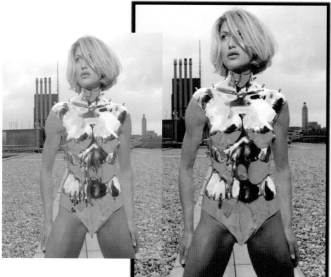

Retouching

Retouching has always been used extensively in commercial photography. A manufacturer knows that a tin of dog food purchased from the supermarket shelf is perfectly acceptable with the label looking a little torn. But, and this is a big but, we would not think of looking for that particular brand if the billboard, poster or magazine ad was less than perfect. The same principles apply to the way we view commercial images for make-up, cars and kitchen appliances.

For this image the retouching of Paula Hamilton is minimal. Unfortunately her suit of armor is highly polished. On closer inspection, Bob Carlos Clarke, the photographer, his assistant plus an assortment of photographic paraphernalia can be seen. To eliminate reflections in the studio the subject could be tented off, but on location, this is difficult and expensive. An hour or so with Photoshop makes this relatively inexpensive.

Retouching has always been the domain of the highly skilled. Now we no longer need to be able to wield an airbrush or use cotton buds dipped in bleach and a scalpel to remove imperfections that are often unavoidable with traditional prints. I must stress that there is no magic button. Good retouching in Photoshop still requires taking one's time and paying attention to detail. I feel that it shouldn't be an excuse for sloppy origination. The earlier David Bailey quote remains relevant.

Retouching is one of the features of Photoshop that has enormous implications for the process of photographic post production. Not only can we now perform complex photo composites, use the program to replace the darkroom and tone images without the use of toxic chemicals, we can also airbrush and remove blemishes all from the same platform.

This is another Bob Carlos Clarke image for the Powergen celebrity calendar. This time the well-known model Paula Hamilton from the famous David Bailey VW commercial is the subject. Again the aim was to emulate Bob's distinctive printing style.

Bob stains areas of his prints with cotton wool soaked in cold tea. One of his trademark techniques. He says he prefers the color to traditional sepia. By staining rather than toning no halides are bleached. The cold tone of the paper remains in tact with warm colors applied on top.

The scan has been deliberately kept flat to give maximum shadow and highlight detail.

The Rubber Stamp, or Clone tool as it is more commonly known, is one of the clever tools in Photoshop.

Every retouching and image manipulation software package has a version of this useful tool. Cloning samples pixels from one part of the image and places them in another.

With Aligned checked in the options box pixels can be rubber stamped from the surrounding source area into the target area.

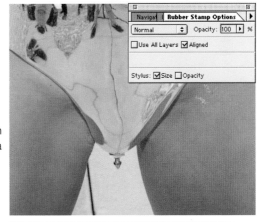

To sample the source pixels, hold down the Alt/Option key and click the source area with the mouse, release the Alt/Option key and click on the target.

With a graphics tablet all the brush tools work in a free flowing style similar to using an airbrush or paintbrush on a traditional darkroom print. Varying the pressure on the stylus gives larger brushes or denser levels of paint as well as some clever distortions and useful filter effects.

The clasps that hold Paula's armor on are rather prominent. One in particular was a little indelicately placed. Bob asked for its removal. Make a selection around the edge of the armor with the Lasso tool. The selection doesn't need to be accurate but close enough to clean up in Quick Mask.

A feather of 1 pixel is sufficient to soften the edge to avoid it looking cut out.

Masking off the area to be protected allows the cloning to be carried out over the area to be cleaned up without affecting the armor.

A traditional retoucher would cut a mask from a piece of card or film and hold it over the area to be protected at just a sufficient distance to allow a little bleed before spraying with an airbrush.

Good cloning techniques only come with practice. Poor cloning can become apparent later if big tonal changes are introduced. It is always worth taking your time when using the clone brush. The source needs to be constantly updated and carefully aligned with the target before proceeding. There is no easy fix. It just needs to be worked on till it's right.

I always work with my left hand constantly near the Alt/Option key which is also conveniently near Command/Z which will undo the last brush stroke if it's incorrect. Much more convenient than going to the menu: Edit > Undo.

I also prefer to keep the brushes box open. Although there are keystrokes for changing brushes, I find a visual reference much better when selecting a new brush.

The masking technique used to remove the clasp was used again to keep some detail present. The armor would have looked impossibly perfect if the industrial setting in which Paula has been photographed were totally removed.

The entire body armor needs to be worked on piece by piece until all traces of the photographer and his equipment are entirely cleaned up. This took me about 90 minutes. I didn't do it all in one go either.

Concentrating on a monitor for such a long period of time is not sensible. Details can progressively escape your attention and the mouse or stylus hand can become tired. It really is a good idea to get up, move around for five minutes, look outside the window and look at nothing in particular.

Here is a before and after clean-up.

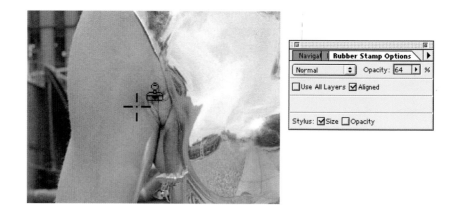

The armor is a little too tight around the armpits, so the creases under the arm need to be cleaned. This time the Clone tool is used at a lower opacity to blend the creases with the rest of the arm. Removing completely would again look impossibly perfect.

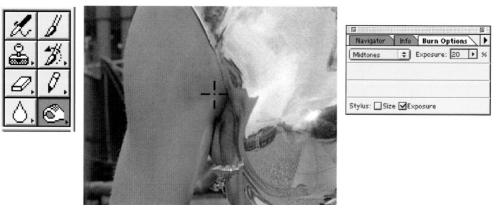

This area is then darkened with the Burn tool. This is similar to darkroom burning in, i.e. adding extra exposure, with a hole cut in a piece of card. Set the opacity quite low and progressively build up to the density required. The brush is set to darken highlights, mid-tones and shadows separately.

As all the brushwork with soft brushes tends to smooth the pixels, I've found adding a little noise helps. Using Wacom Graphics Tablets with pen tools plug-in: Filter > Pentools > Brush-on Noise, noise can be brushed on gradually building up enough noise to blend the retouching with the surrounding area where the film grain hasn't been disrupted. The plug-in works with the mouse but you need to purchase the tablet to get the plug-in.

Once the important retouching is finished, the image was constructed using a layer stack in a similar way to the picture of Hermione – a selection made of the sky, with a tea colored, sepia sky painted in, and a toned layer on top. The opacity of the layers can now be adjusted in the layer mixing desk until the desired balance is achieved.

Tools used
Clone tool
Lasso tool
Quick Mask
Burn tool
Brush-on Noise – third party plug-in

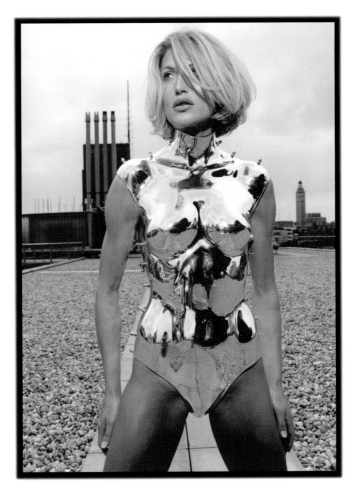

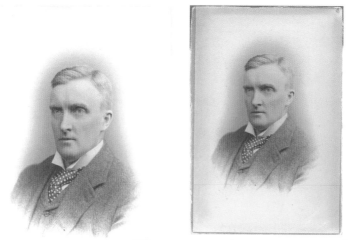

Restoring an old picture

Pete, a friend of mine, asked if I could scan some old family snaps and do my digital clean-up and print thing for his mother. Another favor for a friend. You've got to say 'yes'. While we were playing with the pictures we started to talk about who they were. What did they do? What became of them? Old pictures have always fascinated me. Photography has allowed us a peek at recent history. I informed Pete that I wanted to use Mr Grindle for the book. A little research produced this e-mail.

George Annesley Grindle M.I.E.E. (whatever that means)
Son of Captain Grindle (merchant navy – arrested in 1861 for gun-running by the US federal navy. His wife's father was one-time owner of Schweppes). Son of George Grindle, pharmacist to George III.
1881 – worked for the Brush Electrical Co., and had charge of the first electric lighting in London. Then in charge of Eastern Electric Light and Power Co. in Calcutta, installing DC lighting. He also worked in Egypt.
In 1889 became resident engineer for Messrs Mather and Platt Ltd – in charge of the electrical portion of the city and south London railway. (There's an Underground connection somewhere, too.)
He suggested to G.C. Mott (father of the Underground) that they be electrified. He supervised this work personally.
Director of Chloride 1893–96.
One of the trio of electricians considered the fathers of electrical submarines: Grindle, Golightly and Gilbert. This due to the development of the chloride plate. He was one 'of the best known men in the electrical world at the time'.
Died November 1905 in the SS Hilda, the wreck of which only one British man survived.

This simple portrait of 'anyone' now has a place in history as someone who seems to have achieved a great deal. He had an occupation that greatly changed the life of Londoners. He has now become a real person, more than just an old snap.

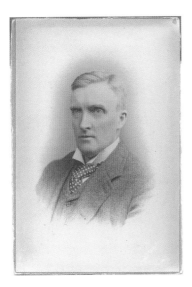

The original print has faded in some areas and the impurities of Victorian photographic papers have left small blemishes. The original print would look different to this. For this image I have chosen to lose all the color and restore a best guess new tone. Apply Channel Mixer: Image > Adjust > Channel Mixer, check the Monochrome box to remove all the color. The file still remains an RGB file.

When opening the image make a duplicate of the original: Image > Duplicate, or click on the original file in its folder and duplicate: File > Duplicate [Command/D] and then open the duplicate file. Keep the duplicate open while making this set of adjustments. The duplicate file will be useful later on when retoning the image.

Rather than remove the blemishes with the Rubber Stamp tool we are going to use the History Brush. Preparing the image for restoring with the History Brush is a bit more labor intensive, but the results are far more seamless.

First of all run a Dust & Scratches filter: Filter > Noise > Dust & Scratches. This removes the blemishes. It also blurs the image. The settings for removing blemishes will vary from image to image. It requires some playing around with the radius and threshold sliders to get the best mix. Try to find a setting that removes most of the dust and scratches but blurs the image the least. I have no rule of thumb for this. I tend to work visually and basically fiddle till I achieve the correct settings. After the Dust & Scratches filter, add noise to introduce grain: Filter > Noise > Add Noise. For this image a small amount of Unsharp Mask will make the noise a little more crisp.

Open the History window: Windows > Show History, or next to the Actions at default pallet settings.

Highlight the edit before Dust & Scratches. History behaves like a multiple undo. We are now back in the past, before all the filtrations that removed the blemishes. Click the box next to Unsharp Mask. The History Brush icon appears. Select the History Brush in the toolbox. We are now going to selectively paint back to the future.

Painting over the blemishes repeats all the filtrations, but only where painted. Use a small brush to just cover the dust and scratch marks.

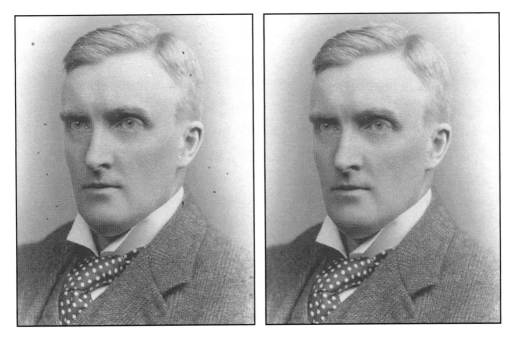

Getting the right mix of the filtrations, then painting over the faults in the original with the History Brush, creates an extremely seamless removal of faults. This is a labor intensive way to retouch, but the results are definitely worth the effort. Experimentation with the filters and the History pallet is a very powerful combination when cleaning damaged originals.

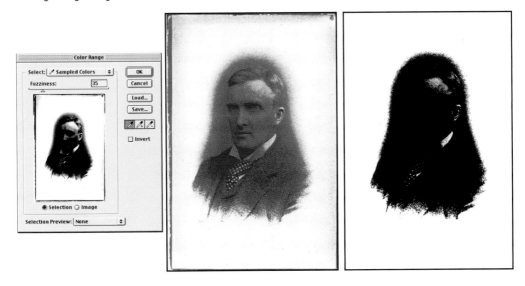

For the next part I worked on a duplicate layer: Layer > Duplicate.

Using Color Range: Select > Color Range, with a tight fuzziness – low number entered – gave a good selection for Mr Grindle but the feathering at the edge was too abrupt.

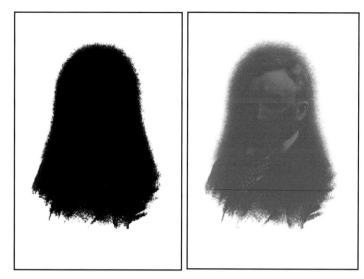

An alternative color range, with more fuzziness, gave a good gentle gradation to the image. The gradation unfortunately bled into the head and shoulders part of the image.

A small amount of minor clean-up around the edges was done in Quick Mask.

After saving both selections, both Alpha channels were combined with calculations: Image > Calculations producing a selection with a gentle gradation at the edge and dense enough over Mr Grindle. Alpha channels 1 and 2 can be consigned to the wastebasket.

With Duplicate Layer highlighted, load the new Alpha channel selection: Select > Load Selection. Delete selection: Edit > Clear [Delete].

There are now three options. Create a layer mask: Layer > Add Layer Mask > Hide Selection. Then tone with Curves in an adjustment layer.

Invert selection: Select > Inverse [Command/Shift/D] creates an adjustment layer and tone with Curves.

Or simply Alt/Option + click on the line between the adjustment layer and background copy. They all work. They will all tone Mr Grindle.

While adjusting these curves it would be useful to have the duplicate image of the original open to get as close as possible to the original tone of the portrait.

At most, this will always be a best guess solution. We have eliminated all the stained background and any of the fading in the image. This is probably close to the original print. Unfortunately the background is a little too clean and perfect to make it plausible as an old image.

To introduce a tone to the background, add an empty layer above the background layer: Layer > New > Layer [Command/Shift/N]. Fill with white at 100%: Edit > Fill.

Add another new layer on top of the white filled layer.

Sample a sepia foreground color from the portrait. Fill the new layer at 100% with the foreground color.

Reduce the opacity drastically to give a hint of sepia to the background. Reduce the opacity of the white to allow some of the background layer to show through.

This layer behaves as a background neutral density filter. Too much of the background would show through with just the sepia filled layer. Although the blemishes have been removed some of the staining and patina of an old print are still in the background layer. Adjust all the layer opacities till a balanced mix has been arrived at. Again this is an over-the-top layer stack but the ability to mix the extremely clean and totally refurbished layer with the background keeps the feel of an old image. Printing on creamy-based watercolor paper with an inkjet printer gives the feel of an old 1900s print.

Tip. If you are using one of the small desktop inkjet printers, set the print head to envelope setting. This helps eliminate ink catching on the fibers that protrude from the surface of textured papers.

Tools used
Channel Mixer
Dust & Scratches filter
Noise filter
Unsharp Mask
History Brush
Duplicate Layer
Color Range
Calculations
Alpha Channel Selection
Layer Mask
Curves
New Layer

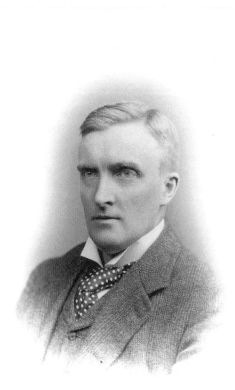

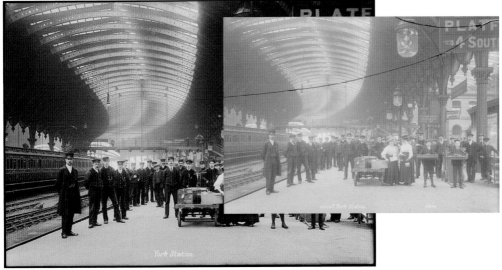

Repairing a glass negative

After a printing session, this lovely picture of York Station, circa 1900, was dropped as it was being put away for safe storage. Alas, accidents happen.

It's almost impossible to butt the joins close enough to obtain a print that could be successfully retouched.

This particular image shot by The Frith Company is part of a collection rescued from destruction by photographer John Couzins. The Frith Company was the pioneer of the modern postcard. John has always had a fascination for large format photographs and has a beautiful wooden 10 × 8 camera made by the Gandolfi Brothers shortly before they died in the mid-1980s.

It is particularly sad that so much history is discarded due to lack of space and lack of interest in our past.

With Photoshop each section can be moved to align precisely and be retouched so that no damage is perceptible.

If photographic prints are desired the file could be written to film and printed in the darkroom. The file can also be output on watercolor paper to emulate a platinum print, as was this picture.

It's a wonderful feeling to give a new lease of life to a picture that has been lost, and for a time largely forgotten.

Scanning the image required careful placing of the pieces of the broken negative as close to the original position as possible. It was more important to place them squarely. This allowed each element only needing to be moved laterally and vertically, avoiding rotation, which is always a little trickier.

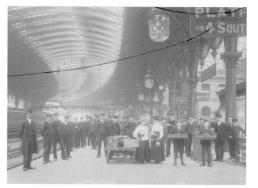

The Magnetic Lasso tool is used to select along the break in the glass.

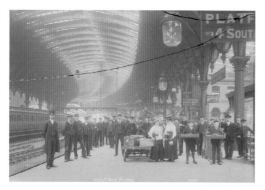

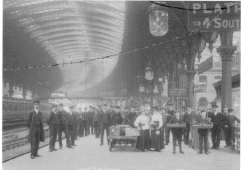

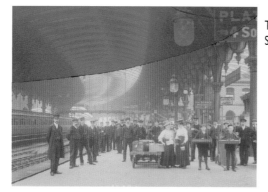

The selection is cleaned up in Quick Mask and saved: Select > Save Selection. Belt and braces.

Create a duplicate layer: Layer > Duplicate. Invert selection: Selection > Inverse [Command/Shift/I] and delete the main area of the duplicate layer: Edit > Clear [Delete]. Float a third layer: Layer > Duplicate.

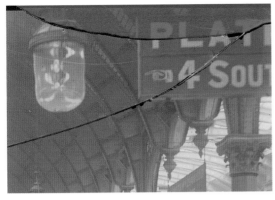

The smaller part of the duplicate is now selected. It is easier with this small selection to toggle Quick Mask and paint directly without using any of the selection tools. Invert the selection and delete the medium-sized part of the negative.

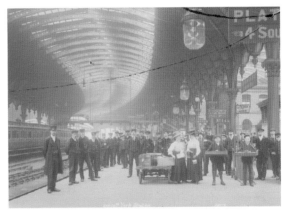

Each element, i.e. the three large broken parts of the negative, are now on different layers. The top right element can be nudged into place with the Move tool.

Using the Cursor keys with the Shift key held down moves the layer in 10 pixel increments. The Cursor keys can now nudge the element 1 pixel at a time until it aligns with the background.

For the smaller element, zoom by dragging the magnifying glass over the area [Command/+] and hand tool [spacebar] to view the required area. Select the Move tool and 'nudge' into alignment carefully with the Cursor keys.

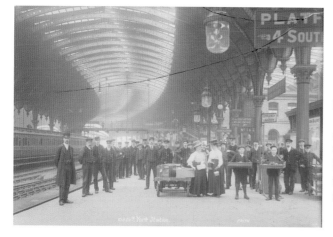

All the pieces are finally aligned. Keep all the separate elements on their own separate layer until all the repair work has been completed.

With a small soft edged brush, use the Erase tool to remove the edges of the layers where they overlap.

Removing the black area gives a very clean join and minimizes repair with the Clone tool. Wherever possible I try to keep cloning to a minimum. In fact I try to keep any invasive pixel editing to a minimum.

I would rather work a little slower with temporary adjustment layers and large layer stacks, trying to leave the big edits to one hit when all the layers are flattened for final output.

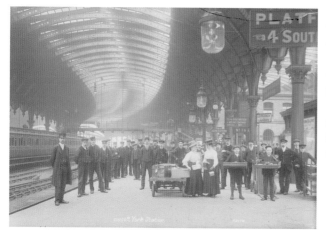

This does require being organized, and forward planning is a must.

Playing with the tools when starting with Photoshop is great fun. After a while it starts to pall. The 'gee whiz' factor goes.

A clearly defined idea of what is required from the image begins to dictate the tools required. Ansell Adams' notion of pre-visualization springs rapidly to mind.

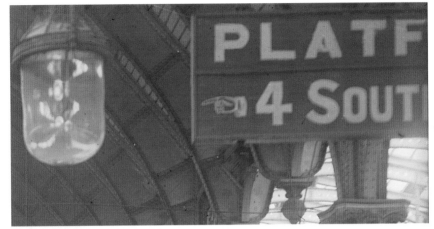

The Rubber Stamp tool is now used to clone small amounts of pixels into areas where the damage still shows. For this part of the treatment I've left the image in three layers and checked the Use All Layers in the Rubber Stamp Options box. Cloning from any layer to any layer can now take place.

With this image I kept the top layer active and cloned from the background and second layers where required.

Turning off the background and second layer shows where the brush has cloned into the empty part of the top layer.

When all the repair work is completed the layers can be flattened.

The Dust & Scratches, followed by Add Noise and cleaning with the History Brush procedure illustrated in the previous chapter, was used again for this image.

When retouching I usually zoom the image to 100% [Command/+] and clean up. An image zoomed to 100% is displaying pixels at screen resolution. For general clean-up work it is best to be systematic. Start at a corner, usually the top left corner and move across the image, clean up, move across until the top of the image is satisfactory. Then move down the image and back across. Repeat till the whole image has been done. It's rather like mowing a lawn in strips. This way nothing gets missed. To scroll the image hold down the spacebar, the active tool becomes the hand tool. It is like reading through a page of text.

The image can be scrolled vertically or diagonally or horizontally. Releasing the spacebar returns to the active tool. With all cleaning and retouching of this nature this treatment is simple but time consuming. There is no quick fix, just thorough application.

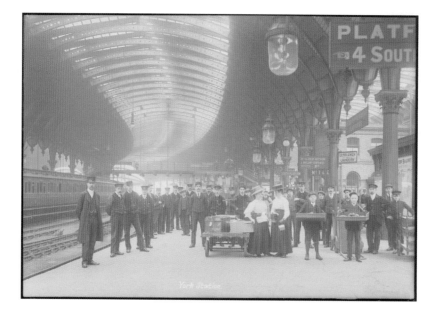

John asked me to add a little grain to break up the image a little. A duplicate layer was created: Layer > Duplicate. Noise was applied: Filter > Add Noise, and the opacity adjusted till the right mix of grain and original image was achieved.

A final adjustment layer with Curves to sepia tone the image was placed on top. Resurrection is now complete.

Tools used
Magnetic Lasso tool
Move tool
Quick Mask
Duplicate Layers
Eraser
Rubber Stamp
Dust & Scratches filter
Noise filter
Unsharp Mask
History Brush
Duplicate Layer
Adjustment Layer
Curves

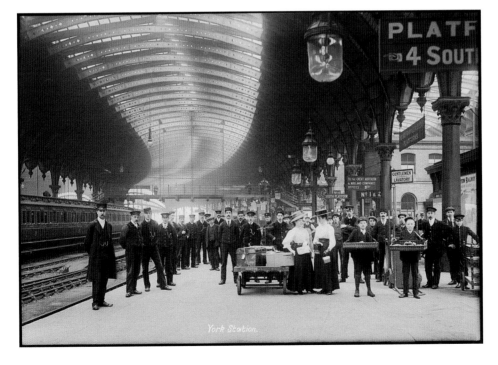

The digital stocking filter

An old Hollywood film trick to smooth skin tones was to film through a soft filter. Photographers of the stars have used the same trick.

Modern coated lenses show every pore in the skin. Quite often I was asked to print through a stocking to emulate the old Hollywood masters. A high-end drum scanner will hold all the detail on the negative, far more detail than is necessary for the look we wanted. As with everything in the analog darkroom, careful use of the Photoshop tools finds a digital equivalent.

This is a repeat of a print that I did for Tobi Corney in the darkroom some years ago. The final print was gold toned on top of a sepia tone to give it a pink color easily emulated in Photoshop. The final print of glamorous Jerry Hall was then framed in a specially distressed gold leafed frame for an exhibition that featured a wonderful shot of violinist Nigel Kennedy mounted in a frame made of broken violins to go with his 'punk fiddle player' image.

With the original, my split grade technique was employed. We wanted Jerry's luxuriant hair to frame her face. Printing her dark just made the print far too heavy. Printing the high-grade exposure through a stocking to gently blur the shadows gave it the depth we required. The digital stocking filter was perfect, and saved the embarrassment of purchasing fine denier stockings.

I was also told that Jerry used heated beer tins as hair rollers. That's the only make-up tip in the book.

This is a simple treatment. Used judiciously, it is a very effective emulation of the photographic uses of lingerie, and extremely controllable.

Take the grayscale scan into RGB color mode: Image > Mode > RGB.

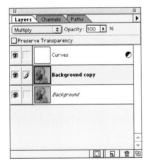

Duplicate layer: Layer > Duplicate, and check Multiply in the Layers pallet. This doubles the exposure.

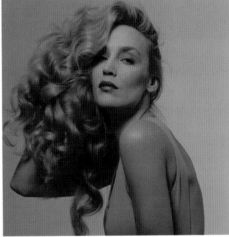

Add an adjustment layer: Layer > New > Adjustment Layer. Check Curves in the drop-down menu to apply gold tone with Curves. Notice the radical pull on the RGB curve.

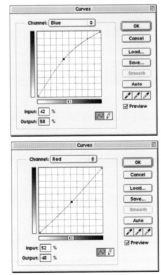
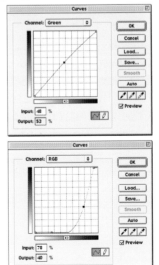

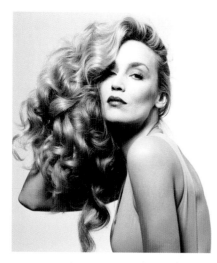

This dramatically lightens the mid-tones. As a result, mainly the shadows are multiplied.

Apply Gaussian Blur: Filter > Blur > Gaussian Blur to the background copy layer.

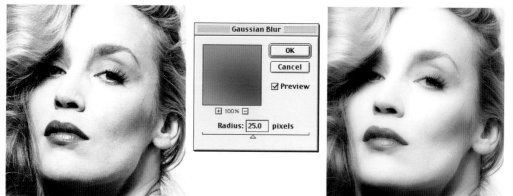

I always go over the top with this filter. The opacity can be reduced to achieve a mix between the blurred layer and the sharp layer. As the highlights have been reduced the pronounced blur is now mainly where the shadows are multiplied in the duplicate layer. If the file is being reproduced small, less blur is required, as the detail from the sharp layer will be lost. With bigger output more blur can be used. The color can change when altering the opacity of the blurred layers. Tweak the curves in the adjustment layers.
Save the file in its layered form.

When cropping, check Fixed Target Size and enter the required dimensions in the crop image options box. To set a final print size I've also entered the resolution of 300 ppi into the box at the bottom of the options box.

A small, curved, double-tipped arrow shows as the cursor is placed near the corner of the crop selection. Rotate the crop, by dragging the corner when this arrow shows.

Complete the image with a black keyline.

Use the Marquee tool to make a selection inside the edges of the image. Invert: Select > Inverse [Command/Shift/I] and fill: Edit > Fill, check Black, and 100% in Fill dialog box.

Notice that the strong diagonals created through the forehead and nose are counterbalanced by the line through the shoulder and hair.

Angling Jerry's head back a little more gives the pose a little more poise and attitude.

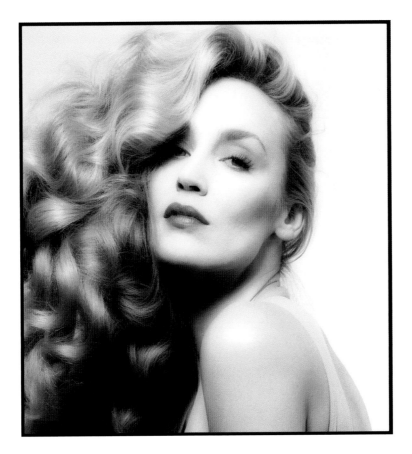

One of the great things about the History pallet, introduced in Photoshop 5.0, is that you can regress to a previous state in the preparation.

The History pallet is more than just a multiple undo. In the flyaway menu: click on the arrow to the right of the History pallet and click New Snapshot. The new snapshot rename dialog appears.

It's a safe idea to rename the new snapshot so as not to accidentally overwrite the previously saved image. We can now explore an alternative treatment.

With this version I made the duplicate layer extremely contrasty by applying a near vertical curve.

Pulling the highlights over near to the center and pushing the shadows is the same as an extreme overprinting of an exposure with grade 5 in the darkroom.

With Multiply checked in the Layers pallet alters all the shadows to nearly solid black.

For the adjustment layer tone, a curve nominally called copper blue, saved from the Microlite image, is loaded. Curves can be saved for future use, with the Save button in the Curves dialog box. They can then be loaded and used again. Although the curves might not be totally correct for the image you are loading them into, they often give a ballpark setting from which to tweak them.

Click the Load button in the Curves dialog and open the curve from the folder you have saved it to.

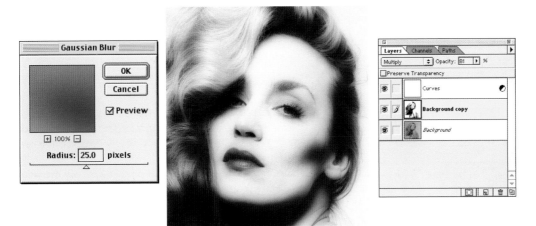

The background copy was once again filtered with Gaussian Blur. If you haven't made any other filtrations since last using Gaussian Blur, the last filter can be repeated with the [Command/F] keystroke. The filtration will repeat at the setting that was previously used. The opacity of the blurred layer is again altered to the correct mix. Notice with this variation that only the shadows are blurred as the highlights were reduced with the extreme curve applied to the duplicate layer.

The black border is dropped in after cropping the image.

Tip. If you want a purely black border, add an empty layer above the adjustment layer and repeat the Marquee selection, invert and then use Edit, Fill. Adding an empty layer below the adjustment layer would give the same blue as the shadows of the image.

Tools used
Mode Change – RGB
Duplicate Layers
Eraser
Adjustment Layer
Curves
Gaussian Blur
Marquee tool
Edit – Fill
History pallet

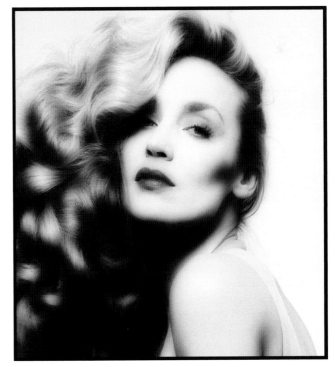

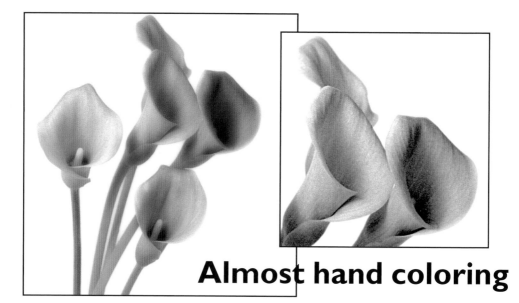

Almost hand coloring

In times past, young women were expected to have deportment, be versed in the playing of the pianoforte and press the odd flower.

In these days of universal suffrage Norma Walton doesn't press flowers, instead she prefers to photograph and give them her unique treatment in Photoshop.

Her gentle images perfectly suit the burgeoning greeting cards market. Instead of trying to compete for mainstream photographic commissions, Norma has found her niche working on the subjects that interest her and placing them with photo libraries.

Working from her home studio and computer suite Norma also shoots catalog work directly for the internet, often designing the website for her clients as well. Located in England's West Country Norma has found that she can keep her over-heads to a minimum and remain in touch with her client base via the internet. Norma's daughter Tanya Carter represents not only Tobi Corney and myself but also keeps Norma up to speed on work in London. Keeping nepotism in the family.

For this image I asked if I could give one of her lovely flower shots a hand coloring treatment of my own. This is essentially a layer stack treatment. With a little lateral thought this simple technique can give rise to many variations.

I've tried to give the image the feel of a Victorian watercolor often painted by young ladies accomplished at the pianoforte.

To have sufficient layers to mess with, duplicate the background layer four times: Layer > Duplicate.

Double clicking on each layer brings up a dialog that allows the layers to be renamed. For this image each layer has the same content. Renaming is the best way of keeping track of which layer is being edited. Turn layers 2 and 3 into monochrome with the Channel Mixer: Image > Adjust > Channel Mixer. Check the Monochrome box.

Before making any further adjustments to any of the layers make an Alpha channel selection. In this example the Blue channel gives the best template from which to make a selection. Increase the contrast with Curves or Levels and paint in the missing detail to complete the Alpha channel selection.

A hint of digital stocking filter helps to degrade some of the photographic precision.

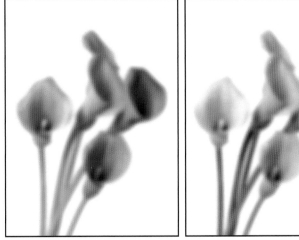

Select the top color layer and run Gaussian Blur: Filter > Blur > Gaussian Blur. Select the uppermost of the monochrome layers and repeat Gaussian Blur simply by using the [Control/F] keystroke. The last applied filter, i.e. Gaussian Blur, is repeated at exactly the same settings.

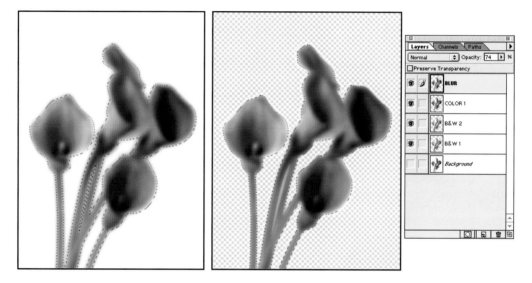

The blur has bled into the background. To keep the background absolutely clean, load the Alpha channel selection: Select > Load Selection, and delete the backgrounds of all the top layers.

Ideally you only need to delete the backgrounds of the blurred layers. To keep it simple I removed all the backgrounds from all the duplicated layers. Soften the edge of the selection first with a small amount of feather: Select > Feather [Control/Shift/D]. Otherwise the clean background will appear too hard edged next to the blurred flowers.

In both the colored layers the outside flowers are removed with the Erase tool, using a soft edged brush.

Many hand colored photographs are often sepia toned beforehand. The monochrome layers could be grouped with a sepia tone in an adjustment layer.

I tried many different versions, often recycling through the History pallet to compare various examples. The basics of this are simple – knowing when to stop is the difficult bit.

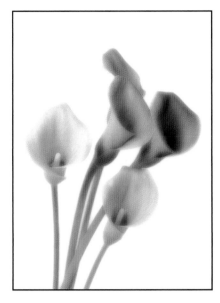

Careful mixing of the top four layers in the layer stack gives a softened monochrome image with some of the flowers appearing as hand colored. Reducing the opacity of the monochrome layers allows a hint of color to show through the monochrome flowers as well.

Tools used
Duplicate Layers
Channel Mixer
Alpha channel selection
Gaussian Blur
Eraser

Gradients

I took this picture of Uluru, more commonly known as Ayers Rock, but now finally known by its Aboriginal name, on a family trip to Australia in 1989.

In one of those revisiting old snaps moods, I decided that this would look pretty good printed at A0 on watercolor paper. I thought the vast scale of an Australian desert landscape was made even more apparent by the tiny size of the rock, which in reality is nearly three miles long.

That particular summer had seen record rainfall in the outback, so the desert was uncharacteristically in flower. Although growing up in Australia, I had never really visited much outside of Sydney; Shepherds Bush now being more familiar to me than the Australian bush.

When viewing a print 40 inches long on a large sheet of watercolor paper, I find myself somewhat overawed by the vastness of my homeland.

Unfortunately the best transparency is in a photo library, so I had to make do with the out-take. It had sat in a cardboard box for some years, was generally banged about and not treated with a great deal of respect. There are a few glitches in the sky area. It also printed with a hefty magenta cast. Rather than try and color correct for the magenta, I decided, given that the sky was fairly even, I could fake a blue sky and get rid of all the nasty little abrasions at the same time with a purely Photoshop invented Gradation.

I no longer have illusions of being a great photographer, I am happy working with great photographers, but the success of this treatment has led to some more images being rescued from the cardboard box. It is reassuring to know that I can take a fair snap.

The first part of creating the gradient for the sky requires making a selection.

For this selection an Alpha channel made from the Blue channel is the best choice.

More contrast is added using Levels or Curves. More contrast gives a good edge to the foreground without any cleaning up. The sky should now meet at the horizon without any gaps.

The rock itself is a little indistinct. Zoom in [Command/+], choose a small soft edged brush and fill in the rock. There are also some small spots in the foreground to be filled as well.

Toggle to a white foreground with the X key and erase the sky in the blue copy Alpha channel.

Load selection: Select > Load Selection and create a new layer: Layer > New > Layer [Command/ Shift/N]. The image is ready to have the new sky dropped in.

Sample the sky near the horizon with the Eyedropper tool. This gives a ballpark tone and color for the sky near the horizon. To correct for less magenta, double click the foreground color to open the Color Picker.

Click on Custom in the picker dialog. I've then modified this color to a Pantone match.

Toggle the light blue to Background and repeat the procedure for the dark blue at the top of the image. I know that the printer should handle this blue without heading too much into magenta. Vivid blues seem to go a muddy magenta color when reproduced with ink. So I am creating a sky with no other colors except Pantone blues which shouldn't create an output problem.

For this bit I have selected colors that seems to fit my memory of the day I took the picture, which is a pretty vague reference. This is an interpretive image on watercolor paper and not meant to be realistic. It is really a cheat. Skies aren't this perfect. Visually the print will work.

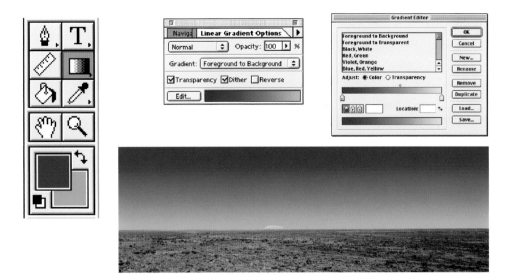

Double click the Gradient tool to bring up the Gradient Options. Check Foreground to Background in the options drop-down menu. Click on Edit and adjust the slider to the right to create a gentle gradation with the dark blue over most of the sky. The change to the lighter blue will be nearer to the horizon. Now fill the sky selection by dragging with the mouse from the top of the image to just below the horizon. A new blue sky with all the abrasions removed.

A final adjustment layer is created to control contrast and tweak the sky, when all the adjustment layers have been made for our layer mixing desk.

Invert the selection: Select > Inverse [Command/Shift/I]. An adjustment layer with a layer mask is created to make color corrections in the foreground: Layer > New > Adjustment Layer and check Curves in the drop-down menu. Load and Invert the selection again: Select > Load Selection, check Invert in the dialog box.

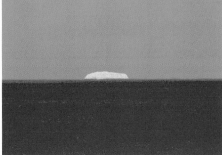

Create a selection for the rock with a soft edged brush in Quick Mask. Use a large brush to paint in the area outside the rock or make a selection with the Lasso tool and fill while still in Quick Mask.

While the selection is active create an adjustment layer to correct the rock by itself. It was an extremely hazy day, so it can get a little lost. The whole point of the picture is the tiny blimp in the middle, which also happens to be the biggest single rock on Earth.

Add Noise to finish the image. Grain needs to be introduced to the sky or it will be too good to be true. We now have our layer stack mixing desk to fine tune all the elements.

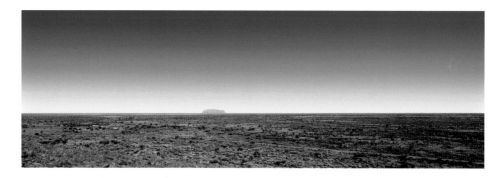

Tools used
Alpha channel selection
New Layer
Eyedropper tool
Color Picker
Gradient tool
Adjustment Layer
Quick Mask
Noise Filter

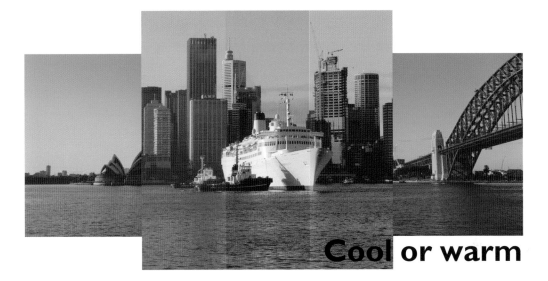

Cool or warm

Fuji lent me a panoramic camera to take on holiday. It was given to me the night before I flew to Australia. These cameras are basically a simple box, with a couple of levels – the bubble type not the Photoshop type – and a large format lens with a simple focusing device. Unfortunately I didn't have time to purchase any color correction filters for the large format lens. Most of the time this wasn't essential as I brought the film back to England and had it processed in-house where I worked and could follow the process.

The first time I used the camera was early morning in Sydney. The film was processed immediately to make sure I had got the hang of everything with this nice new toy.

Unknown to me European film stock has a slightly cooler color to Western Pacific Rim countries. Japanese like their film slightly warmer and as Australia caters to Japanese tourism, warmer film stock is the norm. The E6 line in Australia was geared to this film stock. The E6 technician immediately said, 'From England are you, mate?' – Australians call everybody 'mate' even if they have never met you before, a friendly place – 'Your films a bit cool.' Certainly was. I didn't mind the cooler look; however, I did not like the green color where the sun shone on the buildings and the cruise ship.

Some time later a student with a still life displayed on his monitor wanted to 'warm it up'. An 81A on the front would do it. So this little 'front of lens filter' was the trick we devised. More old transparencies could now be rescued.

Instead of trying to color correct each channel we invented a digital 81A filter. I've made the screen grabs a little over the top to illustrate this. It is best used gently to achieve the best filter emulation.

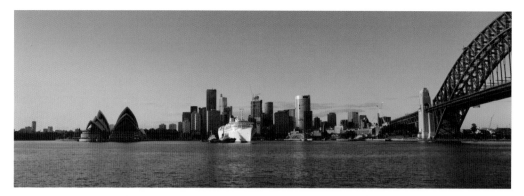

To correct this image the right filter color needs to be created. Double click the Foreground Color in the toolbox to bring up the picker dialog. Click on a blue that will give you a ballpark color. The Custom button will now bring up the Pantone swatches. Choose a color in the Pantone swatch and click OK. The Pantone swatches will give much purer colors.

Add an empty new layer to the image: Layer > New > Layer [Command/Shift/N] and fill: Image > Fill with new foreground/filter color at 40%. Less may do. It will vary from image to image.

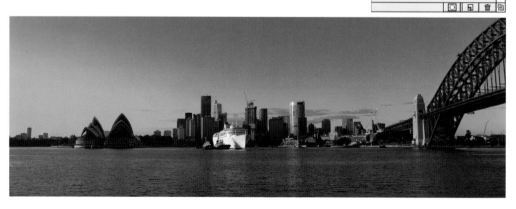

With this image I have illustrated a few variations. Another empty layer is made and filled. Instead of suppressing the yellow content of the green I have tried the option of suppressing the blue by repeating the procedure with a Pantone yellow made with the picker, then Custom button again. The result is checked with the blue layer toggled off.

A third variation was tried by using a red filter created once again with the Picker > Custom > Pantone method. For this variation an adjustment layer was placed under the red filter.

The adjustment layer was used to introduce a little extra contrast. The red filter tended to flatten the subject. The extra contrast also gave the light a stronger directional quality.

These simply achieved filters can warm or cool an image. My final choice was to reduce the blue layer opacity to give enough warmth in the highlights but keep the feel of a crisp early morning overlooking Sydney's skyline. With a little imagination, and a combination of the techniques from these last two chapters, graduated neutral density filters or colored 'grads' could be made, even the ghastly 'tobacco grad' of yesteryear.

Tools used
New Layer
Color Picker
Custom Picker
Image > Fill
Adjustment Layer

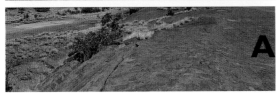

A task made easy

Having seen the Polaroid 'Joiners' of David Hockney and some great pictures of joined panoramic shots, I thought it would be fun to have a go at it while I had the use of a camera that I would probably never be able to afford.

Not being a color printer, I needed to persuade a colleague in the color department to take a day out of their schedule. Unfortunately making a couple of multiple prints from panoramic pictures was just not going to happen.

First it would have required cutting precise masks for each transparency, tying up three large format enlargers for several hours. As well as testing filtrations for three separate color heads and using vast amounts of R-type paper, it became a total nonstarter. A shame really as I had made a joiner of a huge Moreton Bay fig tree on my mother's farm, Circular Quay and an east to west continuous panoramic of Sydney.

Joining up the scans of three separate transparencies in Photoshop is a simple process. The sky needed the same gradient process as Uluru. These pictures had suffered the same abuse in the same cardboard box.

In all it took about two hours, including scanning the images before any ink or paper had been wasted.

It is good to know that I can now assemble my joiners more easily in Photoshop than is possible in the darkroom. All those ideas I had before can now be realized. I am not claiming that this a work of art but it is sure impressive on an A0 piece of watercolor paper.

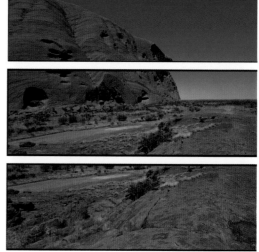

All three separate images were dropped onto an oversized empty canvas and moved until aligned as I wanted. The layers were then flattened to form a single layer.

An Alpha channel selection was made of the sky from a Blue channel copy. A sky was made using the same technique as the image of Uluru in the 'Gradient' chapter. A selection was made of the black edges around each frame and deleted. Finally an adjustment layer was made with Curves checked to brighten the image. All these techniques have been explained in previous chapters.

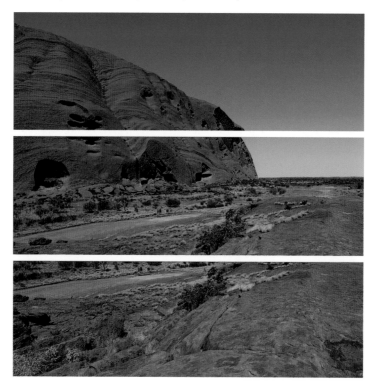

Filters

Filters are everywhere. CDs that grace the covers of almost every graphics and computer magazine have a whole batch of Photoshop plug-ins and third party filters. Usually they are demo versions that expire after 30 days' usage.

The filters that come supplied with Photoshop are more than enough for my uses. I find that most are far too 'gee whiz' for the way I work with images. I do have some plug-in filters and every now and then I sit down and see what they can do and find that after a while I just get bored and get on with my accounts.

This is not to say they are useless. I've seen image makers successfully use many of the pen and pencil emulation filters for graphic effects. This style of filter is probably best used with images that really do require a painterly look.

The well-known poster images for the film *Trainspotting* received an overuse of the wind filter. I found this distressing. The original lith prints took an age to produce by a colleague in the darkroom, and were gold toned by me. The whole image could have been done in Photoshop. The filter was applied to such an extent that all subtlety wrought from the darkroom effort was a waste of time.

I am not against filters, but I do like to see the filter used to enhance the image, not to overpower it.

There are a few, however, that get used constantly. The Dust & Scratches followed by Noise coupled with the History Brush technique used in restoring old images has enormous mileage. The 'Repairing a glass negative' and 'Restoring an old print' chapters demonstrate this. The only blur filter used is the Gaussian Blur filter as used in the image of Jerry Hall in 'The digital stocking filter' chapter. Gaussian Blur is controllable especially with opacity adjustment on a separate layer. The rest run at default settings and I tend not to use anything that has no controllable settings.

I like to have the final say rather than rely on software to make a judgement. See the 'My first image' chapter.

Motion Blur sees occasional use as demonstrated in 'A complex composite image'.

Noise gets a frequent outing when retouching needs to be blended with film grain on a background, or a mezzo screen effect is asked for. See the 'Repairing a glass negative' and the 'Absolut Anzac' chapters.

The Lighting Effects filter is used sparingly. As said earlier, it is a filter that could be made more of. I've started looking at a program called Lightwave, which is a two part program geared to film. The moving element was used in films like *Lost in Space* to produce explosion effects. Unfortunately this requires enormous computing power to render mere seconds of film with any kind of quality. The other part of the program creates 3D objects. I do see powerful rendering programs like this and Studio Max, used in conjunction with Photoshop. Objects could be 'invented', dropped into the picture and relit to match the lighting of the original image. Photographers could reduce their overheads. The need for large studios and model makers could be reduced.

The filter type that is limited in Photoshop is Distortions. Big systems like Barco and Paintbox costing vast sums of money have fabulous distortion tools for reshaping objects. The computing power of recent G4 Macs and multi-processor PCs could begin to handle this sort of added extra. The current batch of filters is capable of some useful distortions but nothing like the big systems.

There is a space here waiting for a clever programmer to fill.

If you have large areas or backgrounds where textures need to be made there are almost too many filters. Kai's Power Tools (KPT) is always worth having a look at. We are now up to the fifth generation of this well-known plug-in. KPT 5 has a useful fabric creation that creates a creditable approximation of all sorts of materials.

Filters are certainly useful, but in my opinion and it is only an opinion, please use filters carefully. Nothing can really resurrect a poor original image or a poorly conceived idea.

Over the next few pages are a sample of the filters available. The first is a cloud image made from the Render filter, followed by the clouds given a thrashing with various filters. This is followed by my cruise liner given some similar filter overindulgence.

All these filters come under the menu command: Filter > Brush Stroke/Distort/Texture and so on.

The first image was made by messing around with the Clouds filter in the Render section.

The next three filters come from the Distortions section.

Many filters have a dialog to edit the behavior of the filter. Some just simply filter to software preset.

The filters on this page are Wave, Spherize and Twirl. These were all filtered from the Clouds image.

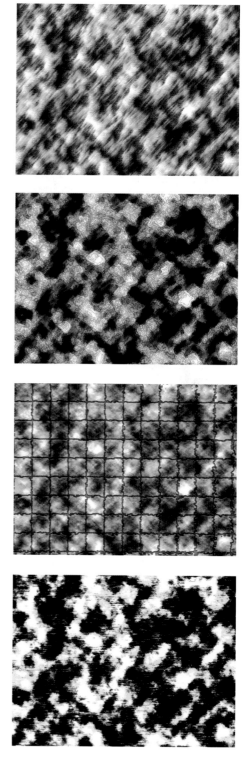

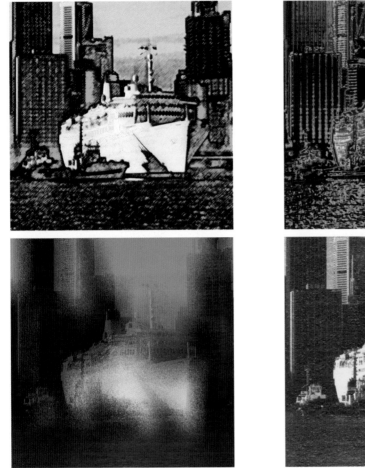
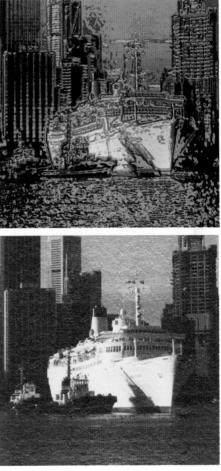

The filters over these two pages are top left to right (opposite page) Watercolor, Rough Pastels. Immediately below are two variations of Ink Outlines.

The next on the left is Paint Daubs. Immediately on the right is Mosaic Tiles from the Texture section. The filter settings allow different sized tiles and a variation in the thickness and the color of the grout binding them. The final two are Crystallize and Mezzotint.

Above, from the top left to right are Charcoal and Chrome. This particular use of Chrome was a little extreme so by going to: Filter > Fade (Filter Name) [Command/Shift/F], the filtered effect is reduced, allowing the underlying original image to show through the filtration. Try it yourself. You never know when you might need a chrome plated ship.

Under these two gems, on the left we have Noise Blaster, which comes from the Tormentia range of plug-in filters, which features such delights as Ripping Pixels and Color Creep. The final is Gold Leaf from the Pen Tool filters that accompanied the software for my graphics tablet.

Although I might seem to make light of these filters, if used intelligently they do have their uses.

Before we leave filters there is one huge filter that is used on every image at some point in the proceedings. Unsharp Mask (USM) is probably the least understood filter. It can make slightly soft parts of an image appear sharper. It is an illusion. No, it cannot bring out of focus sections of the image into focus.

In the pre-digital days of repro, platemakers sandwiched a light, soft negative version of the image next to the positive during the exposure. The Agfa book *An Introduction to Digital Scanning* explains how this technique works. The digital version of USM in Photoshop betrays its early pre-press leaning.

For photographers it could be compared to accutance enhancing developers that give better edge definition. Increased accutance usually comes with extra grain and a tendency to 'halo' near edges of extreme contrast. So it is with USM in Photoshop if overapplied.

When all the editing of an image is complete, USM is added before final output. I rarely apply USM until I know what the output is going to be, quite often leaving it to be discussed with the client and the people handling their presswork. All the images in this book will have an amount of USM added to them but not until I know who is handling the presswork will I ask how much USM or should I leave it to the printers. USM is not just to make the image 'sharper', it should be carefully considered before applying.

Let's explore Unsharp Mask. The first of the sliders is Amount.

This can run from 1 to 500. Obviously the higher the number the more USM is being added. I have given a whole page to magnified examples of this as I think it really is important to see what large amounts of USM really do. I hope that the accutance simile makes sense to photographers.

The first setting is 100% sharpen.

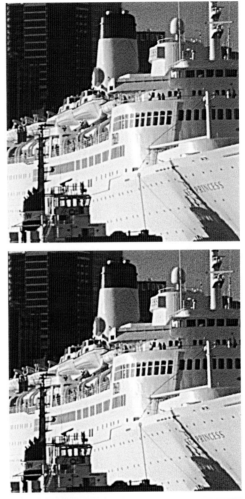

The second is 200%. Somewhere between 100% and 200% is the recommended amount for print repro. This will vary, depending on the image, press, paper and ink used.

The third is at 250%. Notice the increase in noise – 'grain' – and haloing.

The final setting is at 500%. The noise and haloing have become too noticeable.

The next sliders control Radius and Threshold.

An increase in Radius exaggerates the edge contrast more than the default setting of 1. I tend to run it at 3, a little more than the recommended 1–2 setting, when the bleed on porous watercolor paper reduces the effect of the increase.

Threshold determines the smoothness of the sharpening effect. I tend to leave this at 1. I find the effect of higher Thresholds has an unnatural effect that I really dislike. Richard Benson, whose opinion I respect, recommended that it is better to run a lower sharpening amount and run it a couple of times. The effect sharpens the image enough without the nasty halo effect becoming too obvious. I have heard this recommendation several times since. The final image has had 50% Sharpening at a Radius of 3 and the Threshold left at the default of 1 repeated twice. There are many opinions about USM. Talk to your press people. Talk to your bureau. Trust your eyes.

Making his mark

From his home studio near Sydney's northern beaches, my guest Mark Anthony can accommodate three separate photographic shots simultaneously. He can scan his 5" × 4" Polaroid tests, mock up and output an image for visiting art directors. After lunch, clients can take a dip in the pool outside. Mark has found that clients are only too willing to get out of the office for a day's shoot.

Only his beloved Harley Davidson motorcycle, as featured in the opening shot for Apple Computers, remains the only client 'no go' area.

This may seem luxury, but winning many awards, including Australian Photographer of the Year and Australian Digital Photographer of the Year, is the result of being willing to take any commission on board.

Mark realized, when arriving from England, that specializing was not enough to work in Australia. The only solution was to be prepared to photograph anything — cars, food and advertising. Embracing digital imaging added another string to his bow.

Shooting directly for his client's internet presence, with site construction as part of the brief, Mark has now branched out into website consultation and design.

Mark has found, that after years of doing everything 'in camera', the freedom afforded by Photoshop to envisage anything has led to constant work.

Who's missing?

The missing board member has always been the nightmare of corporate photographers.

Business people aren't natural models and often feel uncomfortable in front of a camera. Successful business is not made from hanging around while photographers try to get all the board members comfortable and smiling at the camera at the same time. Business people never seem overly disposed to photographers. Time is money.

The Photoshop solution to photographing a perfect office shot is an ideal way of letting the board go about their work.

The management team was photographed in place leaving a gap for the one missing member.

The late arrival was photographed separately with other photographic crew members placed in the previously filled seats so that he would naturally feel part of a group. The space to his right was left vacant to allow for a good join with the board member next to him.

In the most extreme situations, the office could be shot with perfect lighting and used as the bottom layer in your Photoshop layer stack.

Each member could be lit sympathetically with each of the best shots being composited for the board in full accord. Everybody happy and smiling instead of the usual grumpiness from hanging around waiting.

With every shot on the same film stock and processed at the same time should eliminate color correction. Just don't move the camera.

A longer day and bigger fee for the photographer but minimal time wastage for the captains of industry.

Not another computer!

One of the most common photographic problems is how to make the ever necessary IT shot interesting. All modern business feels it is important to demonstrate that they have an internet presence and are bang up to date with information technology. The computer operator at his workstation is ever present in today's corporate reports.

Mark has avoided showing the computer almost entirely, by showing the young operator hooked up to internet communications with headphones and a direct involvement with his workstation by standing over his keyboard instead of just sitting down.

The shot of the operator is lit for one element of this five part comp. The computer monitor is lit for the other half of the background. Doing this in camera can be difficult and time consuming with the lighting being changed between exposing for the model and then exposing for the monitor for each frame.

Getting the model's expression right first and then lighting the monitor makes life much easier. Stripping these two together in Photoshop does not present a difficulty as the position hasn't changed, just the lighting. The monitor glare is easier to achieve with a simple Alpha channel selection being lightened with Levels.

Three different shots of a globe showing Europe, America and Australia were done later in the studio. Each globe is cut out and optimized separately then dropped into the monitor glare. Finally the image is completed with a few highlights gently brought to the operator's face with the Dodge tool used at a low setting.

A totally modern IT image without the ubiquitous gray box on show.

175

Corporate cover

The covers of corporate brochures often need to have pictorial interest in the center of the page with space left for the corporate banner and type to be dropped in.

The basic image was photographed with a large panel where the flat screen monitor will be later comped in Photoshop.

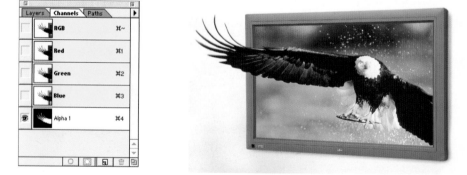

A separate image is made from a scan of a transparency used in a brochure about the monitor. The type has been carefully cloned out with the Rubber Stamp tool and floated on a separate layer over the gray wall panel. An Alpha channel selection has been carefully made to select the osprey and the monitor.

An industry award has been photographed separately and floated on a separate layer. This could have been photographed at the same time as the original transparency, but unfortunately it hadn't arrived in time for the shoot. Shooting it later also meant that simpler lighting could be used for the photograph of the office. As any photographer knows, lighting shiny objects has its own unique problem. Shadows and nasty reflections can be removed before the object is dropped in.

With the trophy and the monitor still in separate layers. The small abstract painting was removed with the Rubber Stamp tool. The canvas size was increased at the top to fit the corporate brochure format. The 'new' wall was brightened using a similar masking technique to the previous IT shot of the computer operator.

A small bright area near the bottom of the chair on the right-hand side is subdued with the Burn tool. The image is finally flattened and cropped for the corporate cover.

Perfect suburbia

A major cable television supplier required a perfect suburban house to promote its weekly movie channel.

None could be found so a new one was built in Photoshop from a photograph of a cottage on a new housing development.

Extra shots of the sunlit brick path and shrubs were made. The bricks were then comped together to form sections of a new path and floated into a new layer. The brick path was blended using the Rubber Stamp tool to make a complete path. Smaller shrubs were copied: Edit > Copy [Command/C] and pasted: Edit > Paste [Command/V] and repositioned with the Move tool to cover the fence and make a perfect suburban garden.

The two front windows were enlarged using the verandah window as a model. Large amounts of brickwork in the front of the building were copied from and pasted to cover the tall shrub and the display board.

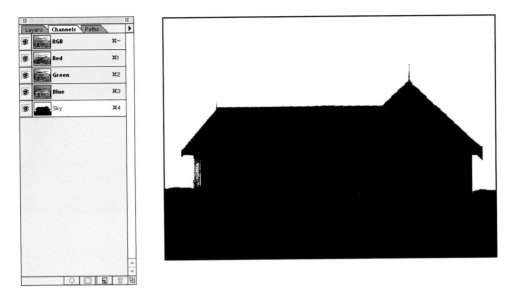

An Alpha channel mask was made by making several selections and forming a complete selection of the house with calculations as seen in the 'Restoring an old picture' chapter.

With the house selected a color correction with curves in an adjustment layer was made to give the house a feel of cartoon perfection.

Using the same Alpha channel selection with Inverse checked when loading, a perfect sunset layer was dropped in. This was given a slightly surreal feel with a curves adjustment layer. The image was finally flattened. Selecting and filling to black removed the window detail.

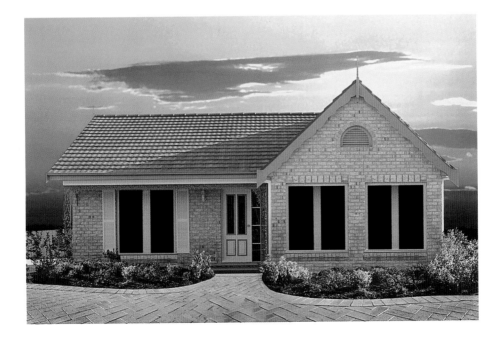

Each week new movie stars are dropped into the blacked out window to advertise this week's upcoming movie attractions provided by the cable channel.

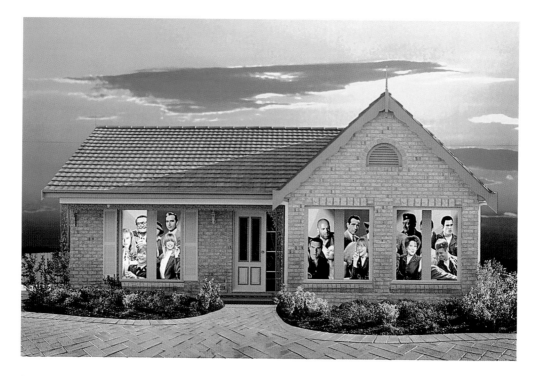

Some elements of Mark's work are carefully sourced from stock libraries. The need for a perfect sunset for his perfect suburbia comes in fact from an old holiday snap that has found a new usage in his professional work.

From all of Mark's images the need for pre-planning becomes apparent. All of Mark's 'in-camera' talents can now be translated to 'in system'.

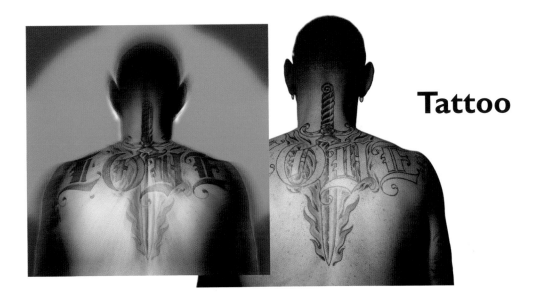

Tattoo

Photoshop has brought an interesting new dimension to the nature of modern image making. One of the by-products of the computer age for photographers is purely economic.

The overheads of maintaining a darkroom can be almost entirely avoided. Large amounts of silver once washed down the sink are no longer required. The large format enlargers I used constantly now gather dust.

The cost of overequipped studios can be reduced. Many effects took hours to achieve in camera. Unless large amounts of Polaroid film are used to ensure that the desired result had been achieved, we had to wait for the film to arrive back from the lab before we knew whether or not an expensive reshoot was on the cards.

Now we can shoot simply and cheaply, knowing that in system the once unpredictable can be achieved and viewed instantly on the monitor. The process can be repeated until the client is satisfied.

The effect of zooming the lens during long exposures is now easy without the expense of complex lenses. It is extremely predictable without having to ask the model to repeatedly stand still during camera manipulations.

Jon Bader, the second of my guests, has achieved exactly that. A cover for a dance music CD has been made from a simple shot of a fantastic tattoo. Jon has used the layer stack method of blending each layer to work with the one above. Once Jon was happy with Stephen, the tattooed subject, the background was built up with layers underneath.

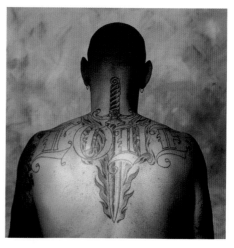

The shot of Stephen from the back was taken on a Hasselblad in the studio against a canvas background.

The subject, Stephen, was deep-etched (Australian for cut out) from the background and pasted into a new layer.

Jon saves his selections as Paths. A selection can be made using any of the previously described methods and made into a work path: Make Work Path, and saved in the Paths pallet – located next to Channels in the default pallet. Paths can be turned on and then made into Selections for editing images.

Unlike Channels, Paths add very little to file size and can be exported with the image into page layout programs like PageMaker, QuarkXpress and InDesign.

As most of my selections are soft edged selections I don't use Paths very often unless the client wants the image to be used as a cutout.

A path was made around the main letters of the 'Love Tattoo'. Using curves in an adjustment layer, the letters were shaded to enhance the tattoo and make it easier to read.

Once again Jon has saved his selection as a path.

The layer with Stephen's cutout back was duplicated. A radial zooming blur was applied – draft mode for bitsy effect to the lower duplicate layer.

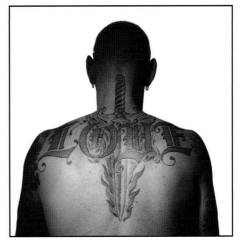

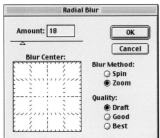

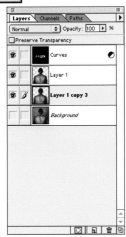

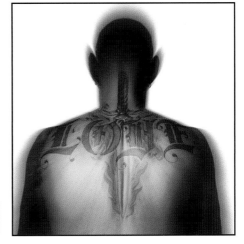

183

The top layer was reduced to 50% opacity with Overlay checked in the drop-down menu to let the blurred layer show through.

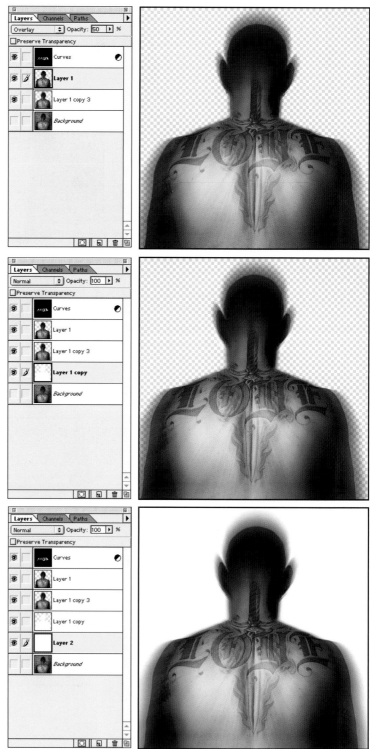

A new layer was placed below the two back layers: Layer > New > Layer.

From the previously saved path a selection was made and filled with white: Edit > Fill.

A Gaussian Blur: Filter > Blur > Gaussian Blur was added for the halo.

A white filled layer was placed above the original Stephen image.

Another layer was made into which 50% gray was filled.

A round vignette was made using the circular Marquee tool, then feathered and darkened.

The vignetted background was then colorized using Hue and Saturation checked in the Layers drop-down menu in a new adjustment layer.

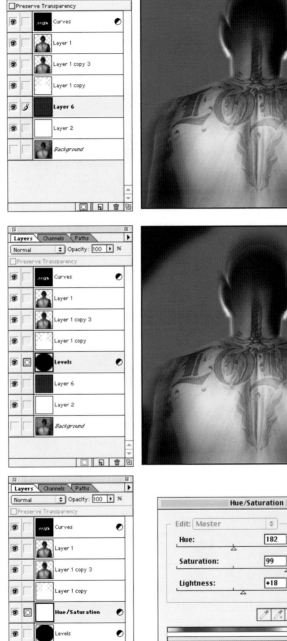

Tattoo image – Stephen Allkins' 'Love Tattoo' for London Records by Jon Bader.

Tools used
Paths
Duplicate Layer
Radial Blur filter – Zoom
Adjustment Layer
Circular Marquee
Gaussian Blur filter
Hue and Saturation – Colorize

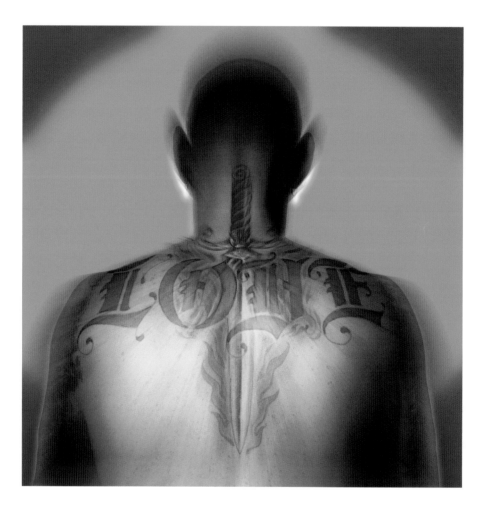

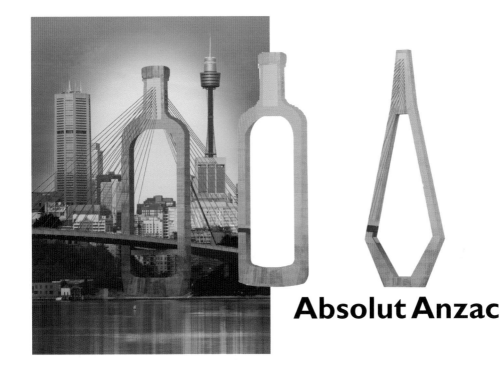

Absolut Anzac

Another image by Jon Bader is a perfect example of forward planning. This skyline doesn't really exist. All the buildings are real, but not quite in this location. Many have been dropped in to give an impression of the central business district of Sydney. The new Anzac Bridge has been carefully rebuilt to look like an Absolut Vodka bottle.

When I asked Jon if I could use this image he explained that he knew what he wanted to do, but as he was new to Photoshop he had to sit down and carefully plan how to achieve it. 'It took me days,' he said. 'Now it's easy. The mechanics weren't hard. I just had to think it very carefully through.'

Jon presented me with a CD of his images containing a brief explanation of his method, which I have adapted to describe the construction of this image.

I think if you have read this book to this point you are probably becoming capable of knowing where the tools are without all the instructions and keystrokes. A description of every tool and setting used in this image would take a book in itself.

Jon uses Paths to make his selections, which I normally don't use. He also uses Hue and Saturation whereas I am inclined to use Curves to color images. Which only goes to show that there is more than one way to build a bridge in Photoshop.

The color shots of the Anzac Bridge and the city were taken at sunset with a long lens on a Hasselblad.

Images of the bridge, the city and the water were chosen and scanned to CD on a drum scanner.

The first thing to do was make a mask of the bottle shape as a guide for remodeling the bridge.

This was done by flatbed scanning an old Absolut ad, and drawing a simple path around the bottle shape.

This was then converted to a selection, then a border selection filled with white and then brought into a new empty document as a floating layer. To see Jon's white mask I've converted it to black.

The Anzac Bridge was cut out from the original scan and brought into the document containing the white outline of the bottle.

With the outline visible over the cutout bridge, the painstaking task of remodeling the bridge could begin.

This was mainly achieved by creating another layer, then sections of stone were sliced from the Anzac Bridge layer and pasted into new layers. These were then distorted with Edit > Transform to fit the template. These slices were built, added and distorted until there were enough to build up the whole bottle shape.

At this stage most of the suspension wires were basically ignored. Except where they could be seen crossing the concrete texture, they were cloned out.

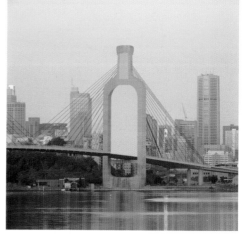

Shadows were added to the completed bottle shape by making a selection to the right-hand edge and darkening with Curves. This gave the concrete slices a three-dimensional quality. This image was brought back into the original scan of Anzac Bridge.

Parts of the city and the original bridge were removed and retouched to leave a clear area behind the new bottle shape.

The bottle layer was turned off. The bridge road was cut out and put on a new layer.

The wires were now carefully and painfully cut out and put into new layers.

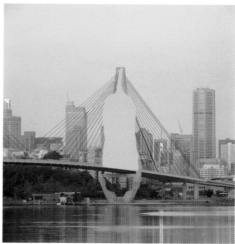

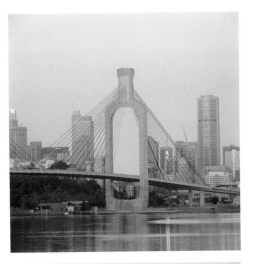

Images of the Centre Point Tower and other buildings in the city were cut out.

These were then imported to a layer underneath the bottle layer, placing the buildings behind the bottle, and then positioned to give a more recognizable city behind the bridge.

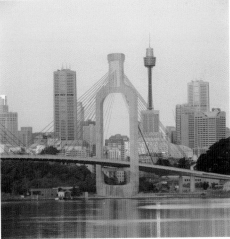

Note. The building on the right-hand side is now covered to make it unrecognizable as the new building imported from the left. It is not in reality there. It still is unmistakably Sydney's skyline.

The bottle layer was now made visible again and the road and wires layers placed on top. The wires and road were retouched to blend with the bottle.

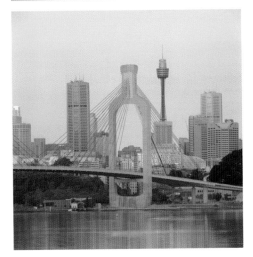

191

Foliage was extended under the road to cover up a building site, stray cars and shipping containers along the shoreline.

Two shots of the water taken at different times and different angles were combined with the original to make the foreground with convincing reflections.

The sky was vignetted to give a brighter area behind the bottle shape falling off to the edges of the frame.

The whole image was given a final 'clean-up' and then converted to CMYK and given a blue tint using Hue and Saturation in Colorize mode.

The final image was flattened before resizing. Noise was added to give some graininess and to blend the edges. The retouching and added layer are now indistinguishable from the original image.

Tools used
Paths
Transform
Rubber Stamp
Duplicate Layer
Adjustment Layer
Hue and Saturation – Colorize
Noise filter

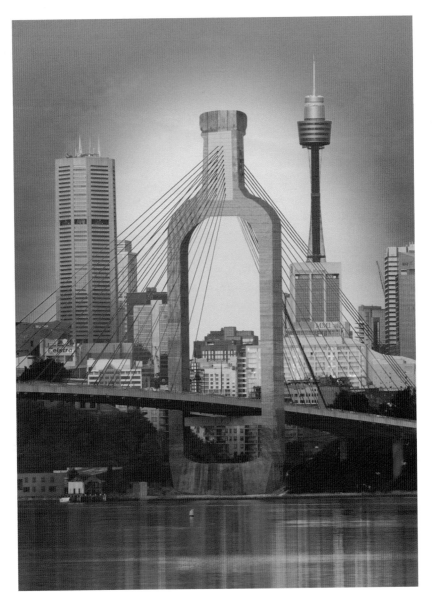

Output

This is the digital equivalent of taking your print out of the fix, slapping it up on the splashback and turning the light on.

Let us have a look at some of the options. I would like to add that this about hard copy, not screen display.

Many of the big powerful imaging computers like Barco and Mamba output images to transparency. This has always seemed futile to me. Why take an image into digital, then output to analog and then rescan it back into digital for final reprographic output? First of all it is expensive. Unfortunately, many art directors seem to be only able to judge an image with a gorgeous large format 'tranny' on a light box. Alas this is not what the final image in the magazine, on the billboard or Ad Shell poster will look like. Why take an image back into analog and then back into digital, creating another generation that will always come with an inherent loss of quality. Hopefully less paranoia towards keeping work in the digital arena will become the norm.

With printing before the digital revolution, images were often copied back onto negative, reprinted, retouched, copied, each generation progressively losing more shadow and highlight detail. If you have ever been fortunate enough to see a first generation print of a Charlie Chaplin film the quality is remarkable. Not the muddy copies of copies that we normally see. The same applies to all analog forms.

Once in the digital realm the loss of information, providing the file isn't compressed, reopened, and pushed around too many times, is minimal. Keeping a master file as a first generation source is advised.

The next series of printers is dye sublimation. My first experience of these devices left me impressed. The quality was good(ish) and the time taken to print them seemed fairly rapid. They were, however, limited in size and had a plastic quality that wasn't too pleasing. They aren't cheap either.

It must be noted that dye sublimation printers originally were 19 inch wide, rack mounted devices designed for military use. They were mounted in tanks to receive satellite information. I believe they were used in the Gulf War in the early 1990s. For this purpose I am sure the idea that they were a little 'plasticky' wasn't a problem.

A cousin of dye sublimation is Fuji Pictography. These devices operate by printing the digital information onto a donor layer, which is then transferred to the receiver layer, a bit like peel-apart Polaroid. The result looks like a C-type (photographic color print paper) print. These are expensive machines to buy. The unit cost of each print is quite reasonable and ideal as instant folio prints.

Then we have hugely expensive LED (Light Emitting Diode) and laser machines. An LED or a laser projects the digital information onto C-type photographic paper.

As a result the print has the same archival quality as any C-type color print. The unit cost per print is quite reasonable and can be repeated without a printer having to enter the darkroom and test each image again. Also the turnaround time on these prints is quite short. There is still life in silver. Durst's Lambda, which uses laser projection, is one of the better known printers of this type.

Another is the Polielettronica Laserlab from Italian manufacturer' Poli, upon which Visualeyes have produced a major retrospective exhibition of Lord Snowdon's work for the National Portrait Gallery in London. Color or monochrome files can be sent to the machine, which prints them on C-type paper.

Tony McLean of Visualeyes informs me that as the Polielettronica Laserlab operates in RGB, the clipping of the color inherent with CMYK devices is not a problem. 'We have no loss of highlight detail as with some LED devices; a good scan gives a good print but as always rubbish in, equals good quality rubbish out.'

Thanks, Tony. I get the picture.

As with all imaging care at the origination stage is all important.

All bureau output, file format, file size, resolution, RGB or CMYK and media accepted, i.e. Jaz disks, Zip disks and CDs being the current favorites, should be discussed with your bureau. Everybody has an opinion, and as with small digital cameras this area undergoes major changes on a regular basis.

Inkjet technology

So far we have discussed bureau only output. The growth area in recent years is inkjet output. When I joined Visualeyes four years ago, as lunatic in residence, the major inkjet output, almost the only inkjet output of real use, was the Scitex Iris Inkjet. This machine was devised as a proofing machine for the reprographic industry. Essentially anything that could be taped to the drum could be printed on, with varying degrees of success.

Iris printing

Graham Nash, former member of the Hollies (a popular English beat combo from the 1960s) and Crosby, Stills, Nash and Young (a harmony singing group, popular with hippies in the early 1970s), took some of his money and formed Nash Editions. Nash Editions had several Iris machines producing prints for photographers and artists such as David Hockney.

The Iris has become extremely popular. The Iris produced print is extremely beautiful, especially on watercolor papers. Careful file preparation could give the visual appearance of an old turn of the century platinum print. The short intake of breath when clients were first handed an Iris was something that I have heard many times. At last here was a machine that could output a digital file and it still looked like art. Gone was the mechanical look of the dye sublimation prints that I had seen four years earlier.

The Iris printer has many software controls as well as many hardware controls, almost too many in fact. The standard ink set is extremely fugitive, i.e. it fades quickly. The nozzles that distribute the ink are extremely expensive and it is a machine riddled with foibles. For quick print on demand it is not the way to go.

The artist David Buckland has an Iris 3047, the largest Iris machine, which he uses to print all his work up to 30" by 47", hence the 3047 tag. David uses a non-standard ink set developed by Lyson which has a great deal more permanence. Camberwell College of Art, who run tests for light fastness called The Blue Wool Test, and have tested these inks, declared that, 'under gallery conditions these inks will last in excess of forty years'.

The Iris is a curious machine and in the wake of recent home and much cheaper commercial inkjet technology by Epson, in particular, as well as Hewlett-Packard, Canon, Lexmark and others, it might seem to have had its day.

The initial buzz brought on by the Iris printer seems to have died down somewhat but I doubt that it is dead. I will let Greg Furney have the final say on Iris prints: 'Whenever I am asked about Iris printing the thought comes to mind "there are Iris prints and there are Iris prints". I've seen some poor Iris operators out there. You need to make the machine your own.'

Essentially the Iris is used for making a one-off four color print, even for black and white or sepia prints. What makes the Iris printer stand apart from most other inkjet printers are two things. First the software that drives the Iris can produce an infinite degree of color control for making subtle variations to the color to meet the most demanding clients' taste, and the way the printer lays down the ink onto the paper stock.

Second an Iris print has a very identifiable crisply defined quality, unlike other prints created with 'coated photographic type' substrates — the paper stock — used by most inkjet printing devices.

The beauty of an Iris print is often the paper onto which it is printed. Hot or cold pressed watercolor paper absorbs the ink into the surface of the paper enabling the image to take on a quality totally unique to Iris produced prints. To really appreciate an Iris print it should be viewed in the flesh.

Keeping in mind that the infinite possibilities of color variation can also create a lot of confusion for the newcomer, the Iris printer is a specialty printmaking device. It takes time and several proofs to get it just right, so if you're in a hurry put it to the bottom of your output options list.

Most photographers who have worked with an Iris printer will know that it is unlike any other method of printmaking. Producing an Iris print is rather akin to producing a beautiful handmade monochrome print with color as an added bonus. Although produced by software from a machine, the print quality appears totally handmade, unless you were to view the print with a loupe.

If a photographer is looking to make a really special image for their portfolio or for an exhibition they should definitely consider working with Iris to achieve a totally unique look.

Once an image has been made to its full potential as an Iris print, the file can be archived to produce the same high quality print for numbered edition prints when required, to be admired for a long time as an 'object of beauty.'

Greg Furney runs Brooklet House Editions in beautiful Byron Bay on the northeast coast of NSW, Australia. Brooklet House produces limited edition prints for artists and photographers. Available on www.brooklethouse.com.au.

'Drop on demand' inkjet printing

Iris inkjet printers spray ink on the paper constantly with a small electrically charged knife edge positioned in front of the nozzles. The charge switches from negative to positive, either allowing ink to hit the paper or deflect into a waste container. This print form has become known as 'giclée' from the French to 'blow' or 'spray'.

The other form of inkjet printer uses 'drop on demand' technology. Essentially it instructs the cyan, magenta, yellow and finally key (black) nozzles where to place each drop of ink as the head moves back and forth across the paper.

CMY works on the additive principle, not the subtractive principle, of RGB. CMY inks in theory should create a black. In practice the inks are never really pure enough. Adding all three actually produces a muddy near-black color. To give a full D max black ink is added as a 'key'. Hence CMYK is CMY and black (K).

There are a number of machines that work on this principle. Novajet is a particularly well-known range. With close inspection the quality appears quite crude, but for display at exhibitions, for example, they are extremely good. Brian Cooke, the owner of Visualeyes, informed me that he had seen scaffolding covered by a massive print on canvas in front of the Doges Palace in Venice. The print was of the Doges Palace without scaffolding. Impressive. Not only was the print put together from large sections, but was weatherproof as well. How public spirited of the Venetians to cover the eyesore of scaffolding in their famous St Marks Square.

At the other end of this 'drop on demand' type of printer is an enormous range of small, desktop, inkjet printers from Epson, Hewlett-Packard, Lexmark, Canon and other manufacturers competing in the home computer market.

I purchased an Epson 1520 three and a half years ago as a cheap alternative to the Iris. Although not in the same league in terms of quality it was certainly in shouting distance and I could have bought over a hundred of them for the same price as a new Iris.

I have printed folios for numerous photographers that, once mounted in their folio cases, are close enough to Iris quality to pass the '30 second test' that is afforded by most agency art buyers. Some prints from my Epson 1520 have appeared in exhibitions in Israel and at the Association of Photographers Gallery in London, looking every bit as good as their chemically derived companions on the wall.

Epson have since brought a range of printers that have fantastic quality and print heads that give variable ink droplet size. At close quarters it is hard to distinguish from film grain. Epson have brought out a printer with its own hardware RIP for proofing.

The main complaint about these printers is that although they are cheap to purchase the user is trapped into using the manufacturers' expensive consumables. Superficially this might seem to be so. Providing you sort out your color management and get your printer set up in tune with your needs, you should get your print right first time, nearly every time. Compared with darkroom consumables the comparison in cost becomes less of a problem. The big plus is that it will print it, the same each time. If you have read this book carefully, your hard work in the darkroom is done only once, and saved for further use. The printer takes care of the trays full of chemicals aspect without too much hassle every time you need a new hard copy.

There are alternatives to using the manufacturers' consumables. Papers are not that much of a problem, but Epson glossy photo paper will be different to Polaroid's glossy photo paper, although not enough to need radical file adjustment to compensate. Inks on the other hand will inhabit different CMYK color spaces to those recommended. The more archival inks tend to inhabit a much smaller CMYK color space than more fugitive inks. As a result, careful adjustment of your files for using 'plug in and play' CMYK conversions will become a problem.

The problem I personally have is that I print on watercolor paper, Arches Hotpress being my favorite. The ink bleeds a little more on non-coated papers, which is why I tend to up the Radius to a setting of 3 in USM. The haloing isn't apparent on a watercolor print. The print is not quite as saturated as the image projected from the monitor.

I have got used to this in the same way as I got used to 'drydown' in the darkroom. I tend to saturate the files a little more before printing them. The other little trick is to put the print head on envelope setting. This raises the head sufficiently so that any little bits of fluff and stray fibers from the watercolor paper don't drag on the print head creating annoying blobs and smears.

I have given my Epson 1520 to my son Matthew and invested in Epson's A3 Photo 1200. This printer runs six inks instead of the regular four CMYK inks. This particular setup features an extra lighter cyan and magenta ink to eliminate loss and banding in the highlights. It also utilizes Epson's variable dot technology. Not only can I now produce photo quality prints on coated papers but have my watercolor options as well. This is not an endorsement for Epson, just my own personal choice. Epson do seem to be leading the way at the moment, having announced the Epson 9000, a 44" wide variable dot printer.

Color management

Color management is a huge issue, which needs to be looked at more thoroughly than is possible in this book. Due to limited space, the glut of opinion and information, I feel a general overview of color management is all that is possible.

Arriving at predictable color from your carefully made Photoshop files is not as straightforward as simply hitting the print button and expecting your desktop printer to give perfect output.

In an attempt to understand this issue I met with Matt O'Donall, a color expert from Epson Australia. During our conversation he explained that not only do you need to calibrate and profile your monitor but also set up your ICC (International Color Consortium) profiles in your Photoshop preferences with your workflow and rendering intent in mind. The conversation brought up as many issues as it answered. We both came to the conclusion that color management applies as much at desktop level as high-end reproduction.

What is color management?

The best explanation I have read is that it is similar to several people talking about the same topic – color – each in a different language which none off the others understands. What is needed is an interpreter. Color management software acts as an interpreter. It can talk scanner to the monitor and monitor to the printer. It can even talk monitor to the printer and then tell that printer to behave like another printer. It does this by using ICC profiles to explain the color space of each device to each other.

What is color space?

Surely color is just color isn't it? Not exactly. When lecturing I stood in front of my class waving my arms about trying to explain that what you see with your eye was far more than any color film could capture. The film speed (ISO), the lab that processed your film and even the brand of film could all alter the color.

Color can also alter at the scanning stage, depending on the quality of your scanner, the software driving it and the settings chosen by the operator. So can monitor calibration and color space chosen in Photoshop preferences.

Then there is more. When RGB are added you get white light. When their opposites cyan, yellow and magenta (CMY) are added you get black. Not quite. In theory you get black. In practice, the impurities of CMY inks give a muddy near-black.

To overcome this ink sets have an added black. This is called a key, hence the term CMYK. Reflective CMYK inhabits a different area of color to projected RGB.

Now there is even more. The paper stock being printed on has an effect on color. Watercolor papers absorb more ink than shiny coated inkjet papers, therefore a change in the color of your output. A map of each area of color from each of these variables is generically called a color space.

What is a profile?

A profile is information tagged to your file telling the color management software about the color space of your file. This can then tell each device – scanner, monitor set up in Photoshop and printer – how to interpret the color information to give it the best translation in its own language. All of your devices need to be profiled so that this interpretation can take place.

RGB to CMYK

The RGB to CMYK conversion is not straightforward. There is not a single way of doing this. At home I use one of the setups in the following Epson and Mac-based printer guide. Windows users will need to do a little more research. The truth is out there.

When my work is going to be converted to CMYK for output, I work in RGB often checking CMYK preview: View > Preview > CMYK to get an overview of CMYK color. This will tell me where the colors are going to be clipped. When you do this you will notice that greens and blues in particular are somewhat duller than in RGB. A profile for the output is often not available so CMYK is left as generic in Photoshop preferences. I never give the bureau a CMYK conversion with this setup. It is purely for reference while preparing the file. As mentioned several times I save RGB files in layered Photoshop forms with curves adjustment layers. If necessary, corrections are made after I have seen a proof.

Generally I try to leave files in RGB with my ICC profile attached and let the bureau handle the conversion for their specifically profiled device. They should understand their machinery better than I do. The ICC profile allows the conversion of my RGB color space to their device's CMYK color space with the best possible translation.

I am not, however, advocating washing your hands of the process but advising that you talk to your bureau about how they intend to manage your color. I would certainly recommend taking a guide print as an example of what you're after. Do realize that this is only a guide print. Different devices will give different results. RGB to CMYK is always a translation.

How much does it cost?

Visualeyes has invested thousands of pounds in Monaco color management software and a spectrophotometer to profile all their various output devices.

I have included a PDF from Monaco on the CD about a much cheaper alternative. With this you can use a basic cheap scanner to profile your system. This is not an endorsement. Monaco has let me use the PDF as an example of a basic closed loop system. There are quite a few similar devices and software packages now on the market.

If this is beyond your budget, at least set up you monitor with the Adobe Gamma control panel. Think carefully about where your work is being used and set the most useful color space in Photoshop preferences.

Do I need to worry about color management?

My answer is an unqualified yes, it will eventually affect all your work especially if someone else handles your output. Although a rather lazy attitude, the bottom line is, it can't hurt.

Further color management reading

For a more thorough explanation it is worth taking time out to download from the internet the color information from *Adobe's Technical Guides*. The technical guide covers both Windows and Mac platforms. This took me about an hour and a half to download and print out for future reference. I now have a 60 page guide to color management issues. There are also some useful PDFs and scanning advice on the same website. These guides cover profiling devices, color space rendering intent and workflow.

I haven't discussed rendering intents and workflow as these are job specific. For the following Epson setup I use Perceptual.

How you set up your system has a great deal to do with how you intend to output and display your work. Make sure you have the facts. I can strongly recommend reading these guides.

Color management is a big topic, and there are a lot of issues that will lead to you scratching your head from time to time. Within six months new software and a different opinion will supersede whatever I write here. If you want to know more check out online forums on www.creativepro.com and www.adobe.com.

Setting up your printer

Here are a few ways of setting up your home printier with some form of color management. I have used the Epson dialog boxes as a guide. Most desktop inkjet printers will have some form of similar dialog.

To run your printer with Photoshop handling the color conversion, make sure your printer driver is not double handling it. First set Space to your printer profile, i.e. EPSON Stylus Photo Quality. Uncheck Printer Color Management. Set the media to whatever media you are using. Watercolor paper users are going to have to run a few trials to find which media setting gives the desired result. Click the Custom button that allows the Advanced settings to be accessed.

Some printers allow you to alter the dpi (dots per inch). This is not to be confused with ppi (pixels per inch) file resolution. This setting tells the printer how many dots per inch of ink to place on the paper, not how many pixels per inch the file resolution is. Although I haven't discussed file resolution, all my 'Final' files are saved at full output size at 300 ppi unless instructed that another resolution is required for a specific device. Larger-sized output often requires a much lower resolution. This 'de-facto standard' resolution allows for upsizing at a lower resolution. Downsizing for web viewing, at a screen resolution of 72 ppi, is obviously not a problem.

Other than the dpi option, ignore the left-hand side of the advanced dialog. Check the Color Adjustment radio button. Where it says Mode, check No Color Adjustment. This way the conversion is done by Photoshop to the printer space, the printer driver leaves the image alone. This is a good basic setup for running your final prints straight out of Photoshop. You may need to run some tests on the dpi option as these printers print at 1440 dpi in one direction only.

When using watercolor paper I ran 1440 dpi, as the porous paper soaks up a great deal of ink. With coated papers you may find that 720 dpi is sufficient. Also if using other non-standard substrates or other printer manufacturers' papers you may have to fool the printer by using another media setting.

Using ColorSync

This next version allows ColorSync to be accessed by the printer driver leaving any Photoshop conversion out of the equation. Make sure that Space has been set to RGB, telling Photoshop to leave the color alone, as it's already in RGB Color. Check Printer Color Management.

Now go into the Advanced settings as before. In the Advanced settings, click the ColorSync radio button. You can then choose your printer profile, and a Rendering Intent. Photoshop will send RGB working space data to the driver, which will then call ColorSync to convert the color to the profile you have chosen, using the Rendering Intent you have chosen. ColorSync will use the CMK you have set in the ColorSync control panel.

ColorSync needs to be understood thoroughly if you wish to choose this route. For first timers use the first version. All the machinery to obtain fine prints is available using Photoshop as the controller.

The settings that are described here come primarily from Matthew O'Donall of Epson Australia, and Bruce Fraser co-author of *Real World Photoshop 5.0*. Bruce Fraser contributes regularly to an online forum on www.creativepro.com.

There is still life in silver

If you still have an enlarger after your investment in new digital kit, here are a couple of variations on a theme that will take you back into the dark. For this, a basic setup is all you need. A cheap enlarger, with a basic timer, a lens that can be stopped down, a pack of Ilford's Multigrade filters, preferably the below the lens type – basically they are laminated and more robust, as well as easier to change between exposures – a safelight and some processing trays and a piece of glass for holding down negatives while contacting.

The first is making negatives for contacting, using your inkjet printer. To some this might seem to negate the whole purpose of becoming involved with Photoshop in the first place.

Not so. The quality of photographic paper is sufficiently different to have a look and feel that shall forever make it wonderful. Above all, photographic paper is extremely archival. A well-processed monochrome will outlast everybody alive today.

This example is of Sue as she is today. The final print is selenium toned.

Prepare your image as a grayscale, you are only going to print using the black ink of your printer. This will work best if you have a printer that will give you an output of

720 dpi or better still 1440 dpi. As this is a method where you contact print, you will need to make your file big enough to print at S/S (same size). You can work larger and downsize but do not interpolate up. The result will be rather coarse. An A3 or a larger printer such as Epson's 1520 or 3000 will give you a bigger negative.

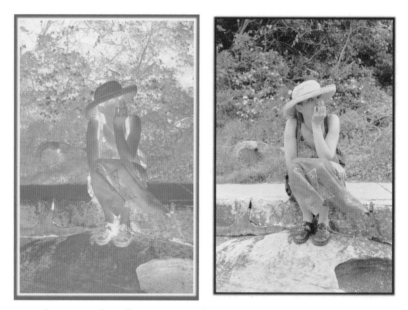

Once you have made all your tonal corrections, added filtrations, montaged and whatever other elements you wish to make your image a work of art, you will need to view it as a negative image on the screen: Image > Adjust > Invert [Command/I].

This is where darkroom knowledge will help. You need to imagine what a negative looks like. If the image is too flat, the print will be too flat. If the negative is too contrasty your shadows will block up and highlights bleach out. All the normal analog disciplines apply here. If you have understood the 'Darkroom' chapter on split grade printing this method would certainly help you make darkroom adjustments to handle your digital negative. You might need to make some trial and error negatives before you finally have the printer giving you the negative required for a good print. Or better still make several different versions of a small image and make a single large negative for contacting.

Should your negative be too thin a duplicate negative layer with Multiply checked will add to the density of your output. The opacity slider can be used to vary the density. Compare it to giving your film more processing time.

The negative is printed on Overhead Projection (OHP) material. Most inkjet printers have an OHP setting. Again you might have to fool your printer by using a resolution setting other than the transparency setting. Do note that ink on a piece of clear film is somewhat different to silver halides on an emulsion.

Once your experimentations are giving satisfactory negatives the final prints can be toned, hand colored and given all the treatments that made the darkroom exciting in the first place.

This will probably not happen the first time you try it. Don't be downhearted, it does work.

Anything worth doing requires effort and careful thought.

The second is a method that uses similar digital techniques to make negatives from digital files. You will need access to an imagesetter. A friend in a pre-press bureau would be an advantage. The negatives are primarily for making platinum prints, but silver-based printing is possible.

Dan Burkholder's *Making Digital Negatives for Contact Printing*

The main problem with platinum has always been that normal print manipulation has been an impossibility. As a contact method using sunlight or specially constructed light-boxes, extremely long exposure times are required. Now with 'Burning and Dodging' in Photoshop as well as all the 'comping' methods, the image is pre-manipulated before the printing stage. I will refer you to America's best exponent of this, Dan Burkholder. His book *Making Digital Negatives for Contact Printing*, now in its second edition, is available over the internet. Dan Burkholder's website address is www.danburkholder.com and well worth a visit.

Dan's book is about preparing your negative for output from an imagesetter. Dan gives all the necessary information for calibrating your monitor, file size, USM requirements and how to brief your bureau for your negative output. There are also lots of printer cheats for preparing inkjet printer negatives. Dan remains an enthusiast of traditional prints, but enjoys the extra range to his creativity that computers allow.

Accompanying Dan's book is a CD for Mac and Windows users, with Gamma curves for platinum and normal silver printing as well as step wedges for judging your platinum exposures. He has also included a file and comparison print that should get you into the ballpark.

As digital technology becomes more commonplace silver bromide paper will become more expensive. All the big manufacturers will go with the marketplace. By comparison

making your own emulsions will become much more cost effective. The craft of fine printmaking has now been given a whole new lease of life.

Dan includes sound advice on how to begin adjusting for your own personal requirements, once you are getting predictable results. With a little imagination you could bend this information for making gum bi-chromates, cyanotypes or any of the exciting nineteenth century print methods. The craft of fine printmaking has now been given a whole new lease of life.

If old print methods interest you, hunt for a copy of *The Keepers of Light* by William Crawford. This book coupled with Dan's presents an exciting combination.

When my commercial commitments have dwindled, this is what I would love to do. Make pictures using the power of Photoshop with the beauty of age old print techniques.

I think this is where I came in.

Appendix

The last word

Always when I give a lecture, write an article and in this case a book something is inevitably left out. Like witty repartee. I wish I had thought of that. Well in this case I thought of it but there is a limitation on space, time and many other minute details, the list is endless.

The perfect book about making images with Photoshop is yet to be written. It would take till Photoshop 8.0 is available, and take up some 1500 pages. Nobody could afford to do it. Nobody could afford to buy it.

It is hoped that you have one of those heavy manuals that gives loads of tips and keystrokes. I have a couple myself, and very helpful they are. I haven't tried to give every possible ramification of computer, printer and plug-in combination. It is just not possible. There is plenty more for a second book. That's for another day. To me, this book was always intended to be a companion to Martin Evening's *Adobe Photoshop 5.5 for Photographers*. I didn't even attempt his detail in the workings of Photoshop. This little book is aimed at making pictures. After the time spent doing this book I would like start making some new pictures.

I have put my own thoughts, ideas and opinions in the first person, as that is the only way I know how to explain anything. From my own experiences. It is not the only way to do things. Try not to rely on the software to do anything. Make the software do what you want. Make Photoshop a creative tool that does your bidding.

Some things have not been dealt with in detail; as the marketplace changes so rapidly there is no point. I hope your own sense of inquiry will lead you to search the internet, discuss with other interested people, and certainly discuss with your suppliers.

There is a list of websites that might come in handy.

My last anecdote is a story about a student in a darkroom class who was moaning about his prints being too dark, too light and generally being dismissive about all the points being made. Eventually I said 'I am not here to make your life easy. If you listen carefully, I just might make your life interesting.'

I hope this book has made life a little more interesting.

Further reading

Photoshop

Realworld Photoshop 5 ... David Blatner, Bruce Fraser
The Photoshop 5 Wow! Book ... Linnea Dayton, Jack Davis
Adobe Photoshop 5.5 for Photographers ... Martin Evening
Photoshop 5 Bible ... Deke McClelland

Great photographic reproduction

Star Trak ... Anton Corbijn
Selected Work .. Peter Lindbergh
Passages .. Irving Penn
Notorious ... Herb Ritts
Work .. Herb Ritts
Images of Spain ..David Tack
Cyclops .. Albert Watson
Maroc ... Albert Watson

Photographic printing

Making Digital Negatives for Contact Printing Dan Burkholder
The Ilford Monochrome Handbook ... Jack Coote
The Keepers of Light ... William Crawford
Photographic Printing .. Gene Nocon
The Master Photographer's Lith Printing Course Tim Rudman
Photographer's Master Printing Course ... Tim Rudman

Glossary of terms

CCD	Charge Coupled Device.
CPU	Central Processing Unit. The processor that drives your computer.
File	Documents are stored on hard drives, CDs and external storage devices as files.

Commonly used file formats

EPS	Encapsulated PostScript.
JPEG	Joint Photographic Experts Group.
PDF	Portable Document Format. Cross platform file format read by Adobe Acrobat.
Photoshop (PSD)	All Layer Photoshop Documents save to this format.
PICT	Macintosh Picture Format.
TIFF	Tagged Image File Format.

Gamma	Measurement of contrast.
Grade	Measurement of Gamma for silver-based photographic materials. Grade 0 has lowest Gamma – Grade 5 has highest Gamma (contrast). Using filtration Multigrade type materials has variable Gamma.
Interpolation	Increase of file size. Software samples pixels and interspaces them with new pixels.
Mac	Apple Macintosh computer.
Mb	Megabyte. Measurement of file size.
PC	Personal Computer. Generic title for IBM-based operating system.
Pixel	Picture element.
Plug-in	Added software – often third party – to increase functionality, e.g. KPT.
RAM	Random Access Memory. Volatile memory, active while computer is switched on.

Useful websites

Adobe .. www.adobe.com
Agfa ... www.agfa.com
Amazon Books .. www.amazon.com
Apple ... www.apple.com
Association of Photographers and Digital
 Imaging Group (DIG) ... www.aophoto.co.uk
Brooklet House ... www.brooklethouse.com.au
British Journal of Photography ... www.bjphoto.co.uk
Canon .. www.canon.co.uk
Creative Pro .. www.creativepro.com
Durst .. www.durstuk.co.uk
Epson ... www.epson.com
Eurocore ... www.eurocore.com
Fender ... www.fender.com
Focal Press .. www.focalpress.com
Fuji ... www.fujifilm.com
Hewlett-Packard .. www.hp.com
Ilford ... www.ilford.com
Kodak .. www.kodak.com
La Cie .. www.lacie.com
Lexmark ... www.lexmark.co.uk
Linotype ... www.linocolor.com
London College of Printing ... www.lcp.linst.ac.uk
London Underground ... www.londontransport.co.uk

Marshall .. www.marshallamps.com
Meta Tools .. www.metatools.com
Minolta .. www.minolta.de/europe.html
Monaco .. www.monacosys.com
Nikon .. www.klt.co.jp/nikon/eid
Pantone .. www.pantone.com
Photo Technica .. www.phototechnica.com.au
Polaroid .. www.polaroid.com
Planet Photoshop .. www.planetphotoshop.com
Tanya Carter .. www.photo-agent-tc.demon.co.uk
Tony Stone .. www.tonystone.com
Visualeyes .. www.visnet.co.uk

Photographers

Mark Anthony .. markanthony.com.au
Jon Bader .. www.contacts-pro.com.au
Dan Burkholder .. www.danburkholder.com
Bob Carlos Clarke .. www.cooltide.com
Tobi Corney .. www.photo-agent-tc.demon.co.uk
Martin Evening .. www.evening.demon.co.uk
Max Ferguson .. www.powermax.f9.co.uk
Spencer Rowell .. www.spencerrowell.com
Norma Walton .. www.walton.demon.co.uk

Index